Steve Sint's

Tips, Tricks and Hints
101 Secrets of a Professional Photographer

Magic Lantern Guides

Steve Sint's
Tips, Tricks and Hints
101 Secrets of a Professional Photographer

Steve Sint

Magic Lantern Guide to
Steve Sint's Tips, Tricks and Hints:
101 Secrets of a Professional Photographer

A Laterna magica® book

Second Printing 1998
Published in the United States of America by

Silver Pixel Press®
A Tiffen® Company
21 Jet View Drive
Rochester, NY 14624

Layout and Design: Buch und Grafik Design, Munich
Printed in Germany by Kösel GmbH, Kempten

ISBN 1-883403-18-9

®Laterna magica is a registered trademark of
Verlag Laterna magica GmbH & Co. KG, Munich, Germany,
used under license.

Contents

Dedication

The thoughts and ideas expressed in this book are distilled from 25 years in the trenches as a professional photographer. My style is the conglomeration of many photographer's styles that have gone before me. While I can't thank everyone there are a few people who must be mentioned. My Mom and Dad taught me the importance of being able to communicate. My sister and Aunt Natalie showed me how fulfilling it can be to teach others. Some are gone now but they live on through me. My good, departed friend Peter wrote a review of a portraiture seminar I gave. In that review he suggested "it should be a book." My friend Barry called to read Peter's review to me and emphasize Peter's comment... I might have missed it on my own. My daughter, Julie, made sure I wasn't intimidated by my Mac and my son, Jon, was always ready to have a game of catch when I had to get away from the keyboard. To these and all the others... this one's for you.

Foreword

No one tip in this book is going to make you a Pulitzer Prize winner. What this book can do for you is make each assignment easier, faster and, more importantly, it will give you peace of mind. While no one tip will change your photography drastically, if you use them you'll find that you are more organized *and* more relaxed! When something breaks and it *always* does, many of the tips in this book will help you before, during and after the calamity occurs. When a client rolls his eyes and tells you that you have 10 minutes to shoot something that you know will take 20 minutes, the tips in this book will help you to compress time.

Finally, most of the tips in this book are part of my photographic lifestyle. You may have tips of your own you would like to share. I'd like to hear them so please address them to me, c/o the publisher. Most of all, think of your photographic style as a system that you are constantly trying to improve. Keep your head in the game. If you are constantly striving to get better, it never gets boring. Good luck and good shooting.

Camera Tips, Tricks and Hints

Zip-A-Line for Masking a Viewfinder

Very often a professional photographer is only using part of the available film format. This isn't the by-product of poor framing but it's because the proportions of the finished picture don't match those of the format in use. Let me give you some everyday, garden-variety examples. If you make a full-frame enlargement from a 35mm negative, you'll discover that it doesn't fit perfectly onto 8 x 10 paper. This is because a 35mm frame is 1 x 1-1/2 inches and an 8 x 10 is proportionately 1 x 1-1/4 inches. Fill the 8 x 10 piece of paper and you are shooting 1 x 1-1/4 inches... every time. If you shoot the 2-1/4 inches square format (Hasselblad, Rollei, Bronica, among others) and deliver 8 x 10 prints to your client, you are really shooting 2-1/4 x 1-3/4 inches (approximately) whether you crop the photograph vertically or horizontally.

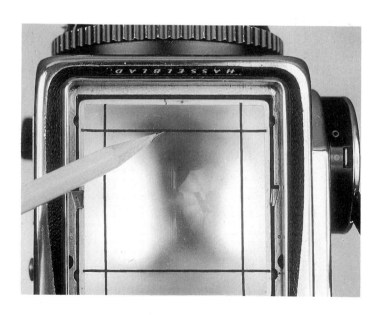

Because of this, I wanted a way to mask my viewfinder to the finished proportions of my final prints. I needed this information so I wouldn't accidentally cut Aunt Tillie from the family photograph. It would be better still if this masking was so subtle that I could ignore it when I wanted to use the full-frame.

My local art supply store came to the rescue. Most of these shops carry a graphic arts product called Zip-A-Line™ which is thin colored tape used to create graphs and borders. Zip-A-Line comes in a variety of widths and colors. The thinner versions were perfect for me, and the color didn't matter at all. I used 1/32 inch width, but you can use any size that works for you... just remember... thinner is better.

Here's what I did: I carefully removed the viewing screen from my camera and cut pieces of Zip-A-Line to fit the screen. Because it's sticky (it's tape, remember) I placed it in position on my screen, reinstalled the screen, put my prism back on (that's the way my camera works) and was ready to take pictures. On my 35s the Zip-A-Line takes about 1/8 inch off the right and left of the screen's long dimension. In 2-1/4 square I use 4 pieces of tape (two vertical and two horizontal) to define vertical and horizontal compositions. When I shoot a vertical, I ignore the horizontal tape and vice versa.

I leave the tape on permanently but that doesn't stop me from adding more tape to define an area for a specific shoot. One assignment called for a finished image that was 12 inches wide by 2 inches high. For that photograph, I masked a 2-1/4 x 7/16 inch band across the center of my frame. Everything outside my lines didn't matter. In my business, the area inside my tape boundary is called the "live area" and everything outside my lines is called... well... dead. It sure makes things simpler knowing that you are not unintentionally amputating a part of your subject.

2 Bayonet Starting Points

Some accessories are mounted on the front of a lens with a bayonet. While this makes attaching and detaching things quick and easy, some manufacturers have taken the idea one step farther and created accessories, such as lens hoods, that must be bayoneted on from a specific starting point. The advantage is that the lens hood matches the film's format which means that you can use a longer hood than one that attaches any which way.

Some manufacturers put a small dot on the edge of a lens hood so that it has a 12:00 starting point for attachment. If the dot is tiny and red, it all but disappears in dim light, making the search for it frustrating.

When I'm faced with this dilemma I add a strip of 1/4 inch white tape that radiates straight out from the lens hood's red dot. The tape is easy to see in the dark but even in total darkness, when I

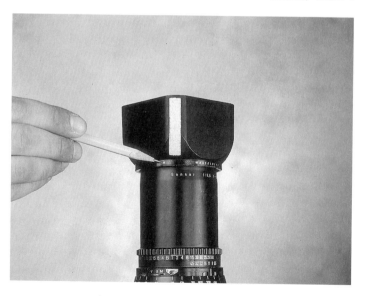

can't see the tape, I can feel it. It's amazing how well a 2 x 1/4 inch piece of tape works.

3

© Steve Sint

Cutting Corners on Lens Hoods

One of the often forgotten but most needed accessories for crisp outdoor pictures is the lens shade or lens hood. These range in style and shape from extension bellows types to collapsible rubber. My favorites are the rigid kind. The funny thing is that camera manufacturers, in an effort to make hoods more compact, make them smaller than they have to be. The best lens hood will extend outwards as far as it can without causing vignetting in the photograph. When I was a young photographer I bought a 400mm f/6.3 telephoto lens that came with a 2 inch deep lens hood... the lens' performance was pitiful. I cut an 8 inch wide strip from black con-

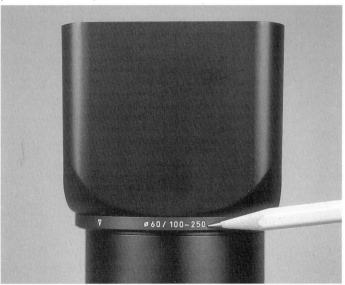

struction paper and wrapped/taped it around my lens. Amazing! Photographs appeared sharper and had more contrast; the lens became a stellar performer!

Sometimes a lens hood for a longer lens will fit a shorter lens and still not vignette. A Nikkor lens hood (model number HN-7) for an 85mm f/1.8 telephoto will not vignette when screwed onto a 50mm f/1.4 Nikkor lens. The longer lens hood gives you an extra 1/2 inch of light blocking length. If you use Hasselblad "C" lenses, the lens hood for the 150mm lens will not vignette when used on a 100mm Hasselblad lens. Interestingly, Hasselblad offers this same lens hood for its 250mm "C" lenses. If the lens hood doesn't vignette with the 150mm lens, then it isn't long enough to use with the 250mm lens.

Sometimes a lens hood is designed to fit the format of the camera you're shooting (it's rectangular) and if that's the case there's a special trick you can use to get the deepest hood onto the shortest possible lens. These format-specific lens hoods will appear in the corners of the frame first when used with shorter lenses. The corners of these square or rectangular lens hoods can be taken off with a round file, eliminating the vignetting problem when you use a longer hood than the manufacturer specifies. This is one of the few times in life where cutting corners does a better job.

4

© Steve Sint

The "All-But-Forgotten" Waist-Level Finder

In the old days, BP (Before Pentaprisms) most cameras came with waist-level finders. They are still standard equipment on most medium format cameras, but photographers often opt for the pentaprism instead. While pentaprisms are nice, there are advantages to using a waist-level finder. You can turn the camera upside down, hold it above your head and still see what you're framing. You can put the camera on the ground and not have to lie down behind it to see through the viewfinder. High angle and low angle photographs almost always stand out from photographs taken at eye

level. A photographer once told me (when I was a rookie) that if I wanted great scenics I should get up on a hillside or down on my belly. He was right, but he forgot to mention waist-level finders. Why wallow in the muck if you don't have to?

There are other advantages to the waist-level finder. You can sometimes shoot less intrusive candids when the camera isn't in front of your face. You can even turn the camera sideways and shoot a photo without facing the subject. Finally, when a waist-level finder is used on a camera with a neck strap, you can pull the strap taut by pressing down on the camera while you release the shutter. This allows you to hold the camera more firmly to prevent movement. If you've read the tip about a string monopod you'll realize that this is the same technique in reverse. Here, you pull down (instead of up) to brace the camera.

5

© Steve Sint

Set Screws in Sync Slots

If you're shooting flash and your strobe and camera aren't in sync you're plain out of luck. If you should be on "X" sync but you're accidentally on "M," you've got big problems! Let me explain how it works. In the old days photographers used flash bulbs. When a flash bulb is fired (ignited) it takes a little time for it to reach peak intensity. "M" sync, designed for flash bulbs, triggers the flash bulb a little bit before the shutter opens so that the bulb is burning at its brightest intensity when the exposure is finally made. Electronic flash (strobe) is different. These modern flash units dump their power the moment they are triggered; there isn't any delay before they reach full tilt. "X" sync, designed for electronic flash, fires the strobe as the shutter starts to open.

If you use "M" sync with electronic flash, by the time the shutter opens, the strobe has already fired. When you do this, the result is black pictures... not dark... not dim but instead hopelessly underexposed, thin negatives. YECCH!

Most modern cameras have forsaken "M" sync entirely. How-

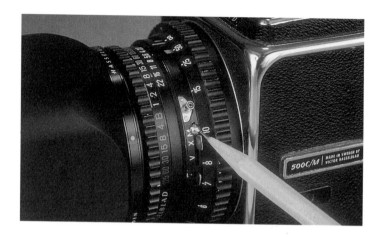

ever, it is still found on some medium format cameras and older view camera lenses have both "X" and "M" sync. It is of utmost importance not to shoot with strobe on "M" sync, especially if you want your photographs to come out.

Over the years, some camera repairmen have snipped off the little "M/X" sync lever on lenses. That way if you want to change from "X" to "M" sync you need a pen point or little screwdriver to make the change. I use older style Hasselblad lenses (I prefer their feel) and they can inadvertently switch from "X" to "M" if you grab the lens the wrong way. This can ruin the photo shoot for both you and your client. To get around this, my lenses have a small screw threaded into the "X/M" slot so it can't accidentally be slipped off "X" onto "M". Be it a snip job or a screw job, it pays to take care of it. It only takes one mistake to ruin your reputation as a pro.

6

A Special Effect With Tape

Special effects are fun. The photographs look interesting and the "oohs" and "ahhs" are music to your ears. One of the easiest to do requires a zoom lens and involves changing the focal length during a long exposure. If you want to bracket the exposure for this zoom special effect, it helps if you can repeat the amount of zoom. If you decide not to use the entire zooming range of the lens things become a bit more difficult. To get a repeatable amount of zoom, I borrowed a trick that the movie guys use for follow-focus. It works with any zoom lens with a separate zoom control (a non-push-pull zoom).

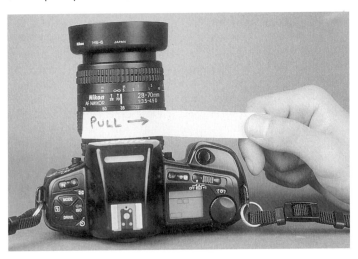

On a movie set, if an actor has to walk towards (or away from) the camera during the scene, the assistant cameraman has to change the focus during the action. This is called follow-focus. If the actor has a specific ending point to the action, cameramen have a simple way to always stop focusing at the right point. They

carefully focus the camera at the ending point of the action. Next they stick the end of a strip of tape on the footage scale and refocus the lens to the beginning point of the action, all the while "spooling" the tape onto the lens. When the real action starts, as the actor moves the assistant cameraman pulls the tape which in turn changes the focus on the lens. As the actor reaches his (her) final position, the tape unsticks itself from the lens and the refocusing stops, always at the right point! This is going to sound funny but the whole thing is really cool!

Guess what? The idea works with a zoom ring also. If you decide to start your zoom at 35mm and end at 80mm, simply set the lens to 80mm, attach the tape and rotate the zoom ring to 35mm spooling the tape as you go. During the exposure you pull the free end of the tape and the lens zooms to 35mm at which point it stops because the tape lets go every time! I, personally, have found that it is much easier to control the speed of the zoom if I'm pulling on a piece of tape instead of trying to rotate the lens ring. The straight versus rotating motion is easier to control and I get the ending point I want without ever overshooting it or having to look.

7

© Steve Sint

Use a Mirror to Check Your Rangefinder

In the old days, photojournalists used rangefinder cameras. Back then, even 4 x 5 cameras had a rangefinder. The scary thing was knowing if your rangefinder was working and if it was consistent over its range from infinity to close up. There were (and still are) two simple tests that go a long way to putting your mind at ease.

The first test for a rangefinder is the infinity check and that only requires going outdoors. Find something very far away like a street light (not the first, second, or third, mind you, but the one at the very end of the block). Next focus your rangefinder camera on that item and check to see that the footage scale on your camera is aligned with the infinity marking. This test is tricky because

sometimes what you think is "far away" is not really at infinity. For this test, look for something really far away. If your infinitely far away subject is shown in your rangefinder as being in focus when your footage scale reads infinity then you have just checked on your rangefinder's accuracy at one end of the spectrum. Now, is the rangefinder consistent?

To check this, pick two distances on the lens' distance scale, one of which is twice the other (such as 4 and 8 feet). After you come up with these two distances, find a wall mirror somewhere in your house. Set your camera to the greater distance and, looking through the viewfinder, walk towards or away from the mirror until your reflected image is in focus. Now, without moving, shift the rangefinder patch to the edge (or frame) of the mirror and refocus on that. Now read the distance scale. If the distance scale is at the shorter of the two distances you selected, you have proven that your rangefinder is consistent over two distances. You see, if you are 4 feet in front of the mirror, then your reflected image is conceptually 4 feet behind the mirror. These two distances add up to eight feet, which happens to be twice the distance that you're standing from the mirror.

While this isn't a strict check of all the focusing distances a rangefinder has to cover, the infinity and mirror checks always make me feel a little more at ease. You can use this rangefinder check with an SLR that has a rangefinder focusing aid just as easily as you can use it on a strictly rangefinder camera.

8

© Steve Sint

Get a Grip on a Point-and-Shoot

In photography's infancy there was a thing called a "camera obscura." Today, too many pictures are ruined by a "flash obscura!" The reason I say that is I see a lot of people taking pictures with point-and-shoot cameras, and... most of them are covering the camera's flash with their fingers! These offending digits probably ruin more flash pictures than all other snafus combined.

And it can be difficult to pinpoint the problem when looking at the photos, so photographers make the same mistake over and over. As cameras get smaller, the situation just gets worse. There is a way (less drastic than amputation) that you can keep your fingers out of the flash's way.

To prevent "digitally-altered" flash pictures, be aware of where the flash on your camera is. Next, look through your camera at your image in a mirror. You'll be able to see if your grip on the camera blocks the flash. Try various handholds to get your fingers safely tucked out of the way. For me, I've come up with a grip that works well for my tiny point-and-shoots. Look at the photo and either adopt my technique or work out one of your own. Just remember not to block the flash.

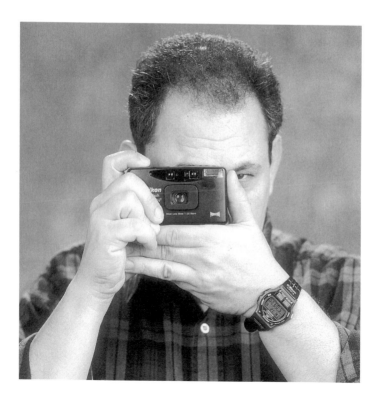

9

Making a Minimum Focus Indicator

Probably one of the most frustrating things when using a point-and-shoot camera is taking a picture of an object that is closer than the camera will focus. You want the biggest possible image, so you try to estimate the minimum focusing distance and you misjudge... by mere inches! Instead of a beautiful blossom filling your frame, you end up with a fuzzy blob.

By using a two cent piece of string and an inch of tape you can make those "blobs" a thing of the past. Here's how. Look in the camera's instruction manual and find the minimum focusing distance for your camera. Cut the string about 1 inch longer than that distance and tape it to the bottom of your camera so that the string's end is under the camera's film plane and the free, dangling end is pointing forward towards the lens. If you want to be really classy

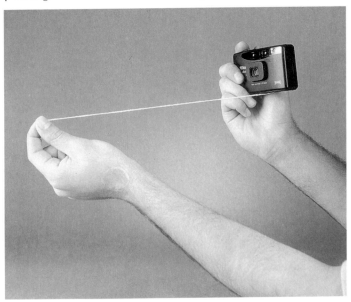

you can forego the tape and screw a short 1/4"-20 bolt into your camera's tripod socket. With this solution, you can tie your string around the bolt (take into account the string used up to make the knot plus the approximate distance from the tripod socket to the film plane). You are now ready to use your measuring device.

Hold your camera in your right hand, finger poised on the shutter release. With your left hand extend the free end of the string so that it is taut and then move yourself in and out from the subject until the string just touches your subject. Since the length of the string equals the minimum focusing distance, you are as close as you can get and still have a sharp photograph. Drop the string, push the shutter release and... voilá, you have a sharp close-up!

Camera Bag Tips, Tricks and Hints

10

© Steve Sint

Never Ready Cases

I've seen it hundreds of times: A tourist wants to take a picture and starts by taking his camera out of its "ever ready" case. He unsnaps the front panel of the case and swivels the front of the case down out of the way. As this is being done, the camera's neck strap gets fouled up in the ever ready case's front flap and has to be untangled. Seconds later, film information sheets flutter out of the case top (the ones he folded up and stored there). While he's scrambling to recover the film info sheets, the two street urchins pulling their pet goat from the alligator's mouth succeed in their efforts and disappear into an alleyway. OK... he got back the film sheets AND the ever ready case kept the camera safe. Sadly, ever ready cases are NEVER READY!

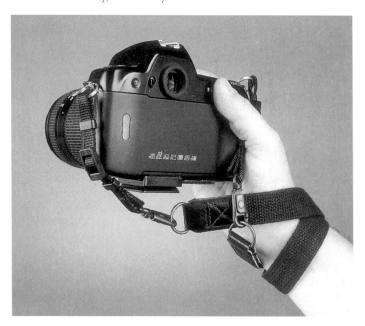

Ever ready cases are no more than a salesperson's pension fund. If you have just a camera and one lens, an ever ready case is perfect for protecting that camera... when it's in the closet or in your suitcase. (A lot of good your camera does in a suitcase!) Trouble is ever ready cases are just plain terrible when shooting pictures and that's what the game is all about. In a worst case scenario, not only are ever ready cases slow to the point of apoplexy but some photographers tape film cans and lens cases to the camera strap making the whole thing a Rube Goldberg type nightmare. If you add to the equation the fact that you have to remove the ever ready case entirely to reload the camera, you can see why this writer isn't "pro" ever ready cases.

Keeping your camera ready for picture taking is the essential element of good street photography. If you are into taking pictures you should forego the ever ready case completely. For my personal photography I take things a step further. I won't even "wear" my camera around my neck; it's too big a billboard. Instead, I wrap the neck strap around my wrist and hold the camera at my side ready to shoot. If you try this technique you'll find that: 1.) the camera is less intrusive to others and 2.) you get a much better grade of grab shot.

11 Plastic Bags in Camera Bags

© Steve Sint

Tucked into my friend's camera bag is a U. S. Post Office Express Mail envelope. Not the paper kind but those plastic ones that are indestructible. He uses it as a waterproof shield whenever he has to put his camera bag down on a wet bench (or wet whatever). He's even used his to create a dry place to sit while waiting for the picture to happen. Finally, my friend is always replacing his plastic envelope because at the end of most of his U. S. expeditions, he Express Mails stuff back home. This means he doesn't have to carry extra paperwork on the plane with him.

When he first told me about this, I too started to carry an Express

Mail envelope in my Domke® satchel. Then I started to put an extra plastic envelope into the bottom of my bag. It keeps moisture from seeping through to my equipment when the canvas bottom gets wet. It's simple and it helps... and you can mail stuff home!

12 Ditty Bags

© Steve Sint

Photo accessories can be found in the weirdest places. A few years ago a trip to my local camping store helped me organize my camera cases. While marching through the store looking for a new backpack, I came upon a display rack with small, nylon, drawstring bags that I knew were the answer to a problem.

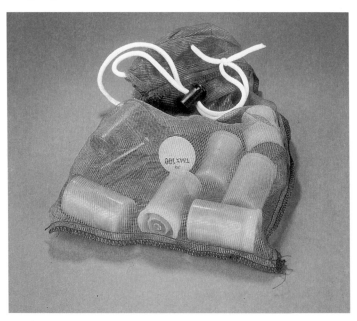

In the outside pouches of my shoulder bags ride a bunch of related accessories. All the tools I need to keep my cameras, lights, and stands together on an assignment used to flop around in one pouch along with spare batteries, Band-Aids™, and sync cords. My tools now ride in a nylon ditty bag. Now, when I need to tighten a screw, the floor doesn't become littered with a rat's nest of sync cords as I ferret for the jeweler's screwdriver. This isn't my only ditty bag, however.

In the same display rack at the camping store I purchased a see-through nylon bag as well and into this I put all my film. When I get to the airport X-ray machine (at the gate) I remove this one bag and hand it over for inspection. No longer do I count out film canisters as I try to hold onto my luggage. One bag... one hand. Isn't organization great!

I even use ditty bags inside of other bags. I often carry a 10 x 22 foot muslin background crumpled into a stuff sack. Inside my sack is a smaller ditty bag that holds all the spring clips I need to put up the muslin. Nothing can make you feel more foolish than dragging a background with you and having no way to put it up. That can't happen to me now!

One last thought before I "bag" this tip. I purchased (at the same camping store) some barrel lock-tie string fasteners through which I threaded my bag's drawstrings. Now, to close a ditty bag, I just squeeze the lock and pull the drawstring through it. When I release the pressure on the barrel lock the bag is shut.

13

© Steve Sint

Carry A Repair Kit

When camera equipment breaks in the field there is usually nothing you can do about it. Put it back in the case, pick up your spare body (or lens... or flash) and keep going. This is especially true with today's electronic marvels that often seem to be made of only diodes and transistors. This being the case, why bother to carry a camera repair kit at all? The truth is, if you don't get totally fraz-

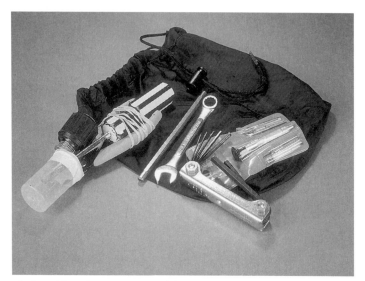

zled and break out into a cold sweat, sometimes things can be righted in a few minutes. Obviously, I'm not going to recommend carrying a soldering iron, circuit boards, and transistors (I wouldn't know how to use them even if I took them along) but a set of jeweler's screwdrivers and a needle-nose pliers might help. This isn't the limit of what a tool kit should have, however.

Many times the part that gives up the ghost isn't our electronic whiz bang but instead a more mundane, mechanical accessory. Often, this little accessory is the cornerstone on which your system is built and a quick fix can put you back in business. Tripods have bolts and/or screws holding them together, light stands and strobe generators have knobs attached with Allen screws, and even a flash bracket is made up of mechanical bits and pieces. It's worth considering the special size tools these items need so that you include them in your kit. In my case, my favorite Gitzo® tripod has bolts that attach the legs to the center column's yoke. In my repair kit there is a small open-ended wrench that just happens to fit the Gitzo's bolts! My Dynalite® strobes have a variator knob (what a variator knob does isn't really important) that's held on with a tiny Allen screw; my repair kit has that Allen wrench included. Bogen® light stands use a different size Allen screw to connect the leg locking devices to the light stand's tubes... my kit includes that Allen wrench. You should get the

idea by now. On an everyday level, in addition to the needle-nose pliers and jeweler's screwdrivers, my kit includes standard-sized Phillips and regular screwdrivers. In my ditty bag, I even have a special tool designed to unjam mechanical Hasselblads.

As I just said, my repair kit has its own ditty bag to keep things organized, but one thing became clear as soon as I assembled my kit. The sharp pointed tools punched holes in my first bag in a split second. To eliminate this problem, my pointy tools are now sheathed in a plastic film canister. I taped the top on the canister and then punched holes in the top of the canister to fit my tools. No more torn ditty bags! Take a look at the equipment you carry and assemble a collection of tools that you need to service them. Your kit can turn disaster into a walk in the park.

A last minute thought: I use a step ladder to pose my subjects and to let me see and shoot over a crowd. My step ladder has four metric Allen screws that hold it together. These screws always loosen up from vibrating in my car. Taped to the side of my step ladder is the proper Allen wrench for the loose screws... always handy.

14 Make an Emergency Kit

© Steve Sint

There are a few different kinds of emergencies, any of which could occur at any time. When you're on an assignment, emergencies can be classified into two categories: equipment emergencies and people emergencies. Equipment emergencies were covered in the "Carry a Repair Kit" tip; now let's think about people emergencies. You might need a safety pin, a bobby pin, a straight pin, a needle and thread, a pocketknife, a Band-Aid™, a rubber band, a quarter, a button, a Tums™ ... an aspirin... an Excedrin™(!) at any given moment. These things can become so crucial that a shoot grinds to a halt "for lack of a nail," you know the story.

Because I hate the taste of ground halt, I make sure my shoulder bags carry a small repair kit for people emergencies. I made mine from a 35mm slide box that I neatly covered with gaffer tape.

I added the tape so that the plastic box would be less susceptible to cracking. While you might use another kind of box, a metal Sucrets™ box comes to mind, the idea is still the same.

What you keep in your emergency kit is up to you. I carry all the things I mentioned above along with my allergy pills! Of special note are the kind of Band-Aids I carry. Instead of the plastic ones, I use the "flexible fabric" type. (The same kind my doctor uses.) They seem to stick better and offer more padding. Additionally, I've found some special types that are designed for the fingertip and knuckle. Since I'm always dinging my knuckles or fingertips, these "customized" Band-Aids really help. Probably as useful as special Band-Aids are safety pins and my kit has an assortment

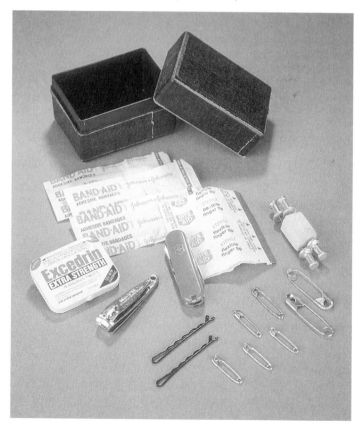

of different sized ones. More than once a safety pin has saved my shoot day, making me glad I had one with me.

© Steve Sint

15 The Loupe In Your Camera Bag

A high quality loupe is a joy to have. Most view camera users have a favorite, and a good loupe is coveted by photographers for viewing 35mm chromes and contact sheets. While many of us use specially-designed loupes, many of us don't realize that we have a great loupe attached to our camera or gathering dust on an equipment closet shelf. I'm talking about a fast (large aperture), normal focal length 35mm or medium format camera lens. Because film is so much more discerning than the human eye, a "photography"

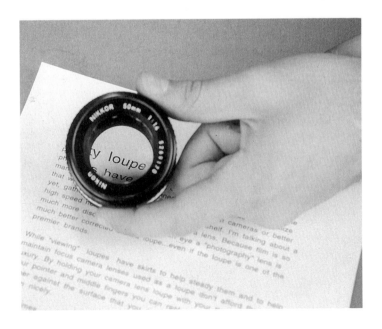

lens is much better corrected than a loupe... even if the loupe is one of the premier brands.

While "viewing" loupes have skirts to help steady them and to help maintain focus, camera lenses used as a loupe don't afford that luxury. By holding your camera lens loupe with only your thumb and index finger, you can rest your other fingers against the surface that you are viewing. This will steady the lens nicely.

A camera lens loupe works better in the reversed direction, looking through the front element, to check prints for sharpness. To view chromes on a light table, look through the rear element. Either way, move the lens and your eye back and forth until you achieve correct focus. Whenever I'm on a location shoot with my 2-1/4 camera, I use my normal lens to view test Polaroids for sharpness. I don't think I'd go through the trouble of carrying a separate loupe, but as long as I have one sitting in my camera bag I'll gladly take advantage it.

16 Don't Go Out Without Your Make-up

© Steve Sint

The idea of make-up sometimes makes photographers shudder. "It's not natural," they shout! "It invades the subject's space," they protest! "I don't have time," they plead! "It often makes better pictures," I tell them. While very few women would complain about makeup, some people feel it doesn't fit into the macho world of men. Well, I know for a fact, that men perspire just as much as women, have the same skin imperfections, and want to look good in photographs. Adding a small amount of make-up can help all three situations. With the help of New York make-up artist Filis Forman, I came up with a small, basic make-up kit that I include in my portrait pack. It has saved the day more than once.

Filis' first suggestion was to carry three or four different shades of translucent powders with a puff for each. These powders don't really *look* like make-up but they do eliminate oily skin shine. You can't look cool as a cucumber when you're all sweaty. Next on

Filis' list is a comb and some hair spray... easy enough. Lastly, Filis recommended a small squeeze tube of Vaseline for lips with no skin flakes. Filis specifically recommends against using anything in a stick because you don't want a make-up stick touching everyone's lips, not very hygienic, you know. With the tube, the subject can squeeze a little on a fingertip and apply it. Another neat addition is a breath spray, such as Binaca™. Breath spray makes the subject salivate and eliminates dry mouth.

Filis made more suggestions that I found helpful. My kit now has a roll of toupee tape (wig tape) included. Toupee tape is double-sided tape that is very gentle on skin and fabrics. Filis uses it to tape the two pieces of a tie together and to tape a man's tie to his shirt. That way, in the heat of the shoot, you don't get a great expression... and a row of shirt buttons! She also added a few rubber bands for shirt sleeves that are too long (sort of mini arm garters) and a lint brush, both worthwhile additions.

If and when you use make-up, it pays to realize that you are invading someone's space and that calls for velvet gloves. Discuss with your subject what you want to do and *WHY* you want to do it. You can't just step in and start flinging a powder puff around. It would seem too much like a Marx Brothers movie.

17 Carry a Flashlight

© Steve Sint

If you have a tripod, one of the most fun and exciting things to do is take pictures at night. Skylines twinkle, fireworks sparkle, and moving traffic becomes a stream of light. Timing these long (very long) exposures requires a watch with a second hand (or a digital counter) and a way to see the seconds tick by (it's night time, remember). Without a doubt, one accessory in my case that gets a lot of use is a small waterproof flashlight (my 5 inch by 1/2 inch diameter, plastic, "O" ringed job is marketed by Argraph). Now many of you will smirk and tell me that your digital watch has a light in the dial that allows you to tell time in the dark. To those of

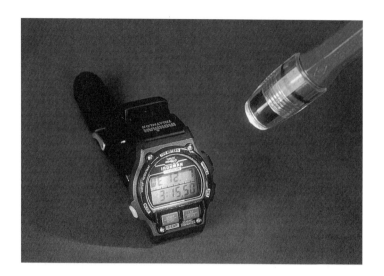

you I say, "well, maybe." Older digital watches have a tiny light bulb on the face (actuated by a push button). There is a problem. Most watch lights are on the hour side of the digital face. That's fine for seeing the hours and minutes, which is fine for normal people, but the light often does not illuminate the seconds readout which is what photographers are interested in. Recently, Timex brought out a series of watches called Indiglo™ where the entire face lights up and you can read the seconds with ease. That means that you don't need the flashlight to time long exposures. I still carry mine even though my kids bought their Dad an Indiglo™ last year. Even though I don't need the flashlight to time seconds, I still need it to load my camera and rummage through my shoulder bag. Shed a little light on things... even if you have an Indiglo™.

Use a Dental Mirror

Extend your tripod so that your camera's top plate is above your eye level and you'll find you can't see the !#%^#&@# settings. Mash your tripod up against a wall and you'll find you can't read the frame counter on your roll film back. There are times, lots of them, when you'd like to be able to look around a corner or stick your eyeball someplace where there is no room for the rest of your

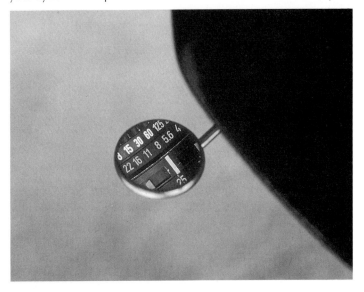

head. A dental mirror might give you the help you need. Dental mirrors (or any small mirror on a stalk) are available in drug stores, hardware stores, automotive shops, laboratory supply firms, or medical supply houses. You might even ask your dentist if he has an old one you can have. The medical quality ones are smaller and better-built but almost any one of them is a good addition to your bag.

19 Modifying a Domke Insert

© Steve Sint

Most every "pro" carries an 80-200mm zoom lens. In fact, to many of us, it is a prime tool that is used so often we dedicate a camera body to that lens so it is ready all the time. The 80-200mm f/2.8 lenses offered by both Nikon and Canon are the size of a thermos. Imagine my discontent when I realized that mine, with a body attached, wouldn't fit into my camera bag and still let the top flap close. It was time for some end-user redesign.

I took the standard, deep pocket Domke® insert and went to work with a scissors. The top of the side walls of my insert were cut into an arc shape (with the arc slightly bigger than the 80-

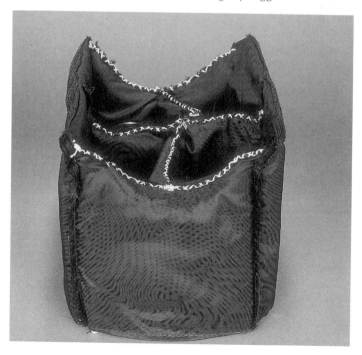

200mm lens diameter) and the center insert walls were cut down so they matched the arc in the side walls. The frayed edges of my cutting job were finished off with a carpet needle and carpet thread which is a heavyweight thread used for... well... sewing carpets. I was almost finished.

To make the soft arc-shaped insert walls capable of carrying my lens/camera combo's weight, stiffening was needed. Using some extra inserts from a Lightware® case, I cut pieces that matched the arc of the insert walls on the top but were flat on the bottom. If you can't find a Lightware insert you can use 3/8" plywood and cover the top with thin foam rubber. Because these pieces fit inside the side walls of the Domke insert you don't see them anyway.

Now, when I pack my Domke, down below ride the short lenses, a body or two, and my strobes. In the cradle formed by my new, modified insert sits a body with my 80-200 attached... ready for action. I must admit that my Domke insert looks a bit like the Frankenstein of camera gear (due to my ability as a seamstress) but it works like a charm. Form follows function. If it functions beautifully, then it is beautiful!

20 Gluing Rear Lens Caps Together

© Steve Sint

Did you ever hear of secondary collision? You are driving your car with a ripe tomato sitting on the seat next to you while you are traveling at 60 miles per hour. You hit a wall! While the speed of your car immediately drops to zero, the tomato is still traveling at 60 mph. Nanoseconds after the wall/car contact, the tomato hits the windshield and becomes tomato juice. While the wall/car contact is a primary collision, the tomato/windshield contact is a secondary collision caused by the primary one. Now imagine your camera bag is the car and your equipment is the tomato.

I can usually fit two short lenses into the compartments of my camera bag. Although the compartment is padded, the two lenses in the pocket are all set for a secondary collision because there is

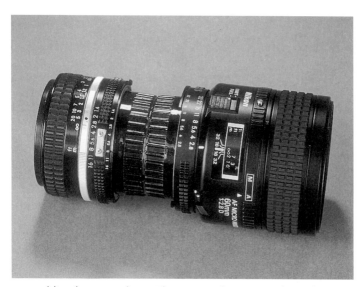

no padding between them. There is a solution; rough up the outer surface of two rear lens caps with sandpaper and then epoxy them together. The two lenses, when capped together, become one unit so they travel together and never smack into one another.

There are other advantages to this tip. Two short lenses fill the deep pocket in a camera bag better. Also, two lenses of the same type can be grouped together for quicker selection. For instance, two wide-angle lenses can travel together or a fast normal lens and a fast wide lens can become cap mates. Telling the two piggybacked lenses apart can also slow you down but a small piece of tape on each front lens cap marked with the focal length can help sort things out. If you go this route try not to mix up your front lens caps or you'll be as lost as ever.

21 Get a Grip on a Stuck Filter

© Steve Sint

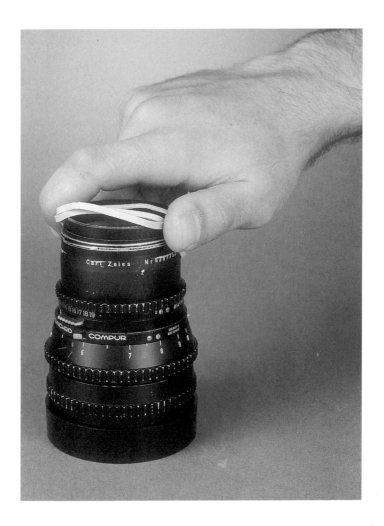

You screwed a filter to the front of your lens, and now it won't come off. A stuck filter is a bit scary. Use too much muscle and you're afraid you'll damage the filter... or worse yet, the lens. You probably will. The solution is not how much muscle you use, but where it's applied. If you could get a "good" grip around the filter your task would be a piece of cake. With a few wide rubber bands cake it is.

In one pocket of my bag I carry a few wide rubber bands that are a great addition to my rig. If one is stretched over the rim of a filter, your grip is greatly improved. Most filters let loose easily once they've been rubber banded. I mentioned this to an assistant and he told me how he had stretched a rubber band over the scalloped focusing ring on an older lens to soften the feel of the focus ring. He used a rubber band from a lobster claw (about 1 inch in diameter by 1/2 inch wide) and had to use three pencils to force the band over the lens... sort of like lens tire irons. Rubber bands... don't leave home without them.

22 Tips With Tape

© Steve Sint

There are so many kinds of tape and it's such useful stuff that most photographers have a roll or two stuck into the corner of a gadget bag. With all the variety it's hard to tell which to carry along; here are a few suggestions.

The standard fodder of the studio or field photographer is gaffer tape which is available through photo supply houses. This fabric-based tape can be used for repairs in the field and is so strong that sometimes the repairs become permanent. While gaffer tape is available in black, white, or gray, I find the gray kind the most useful. It doesn't get dirty like the white but unlike the black variety you can write on it with a marker. While I use all three in the studio, the gray tape is in my shoulder bag. Under no circumstances (except emergencies) should you use "duct" tape in its place. Duct tape is plastic-based, not as strong, more

prone to getting stuck to itself when you rip it from the roll, and the stickum migrates off duct tape to surrounding things (like your fingers) while gaffer glue stays on the tape. Last but not least, on the "plus" side, gaffer tape doesn't melt when placed near hot lights like duct tape does.

Sometimes you don't need the strength of gaffer tape and for my second roll I carry white paper tape available in art supply stores. Easily ripped, white paper tape is perfect for sealing film boxes, writing notes on, or marking a film holder or camera. It can even be used to mask out an area on a groundglass or viewfinder screen.

Whichever tape(s) you decide to carry, there are some tips that will help in its use. You can make a gaffer tape roll smaller by re-spooling it on a film canister; by using the canister you are making the core smaller, which helps in a crowded camera bag. If you use tape to wrap something, remember to fold the last 1/2 inch or so back on itself (stickum to stickum) so that when you go to remove the tape you have a handy pull tab to get you started. Whatever (or whichever) way you decide to handle your tape supply, you'll find it is the best partner you can have for getting a job done.

23 Packing Your Bag

© Steve Sint

Packing a camera bag or an equipment case is a mixture of art, science, and voodoo. You walk a thin line between efficient use of space and having instant access to everything. Added to these opposite goals is the need for equipment and accessories that make the main equipment work and ensure a problem-free shoot. Furthermore, after you've packed and repacked to perfection, some outside force (such as airline baggage handlers) is waiting to screw things up. There are some general philosophies that can help you zero-in on taking everything but the kitchen sink and getting it ready fast.

A photographer friend of mine had two strobe cases that traveled all over the world with him, being bumped through luggage carousels and thrown about by Sky Caps. One day, he de-

cided to reorganize and put all his strobe generators into one case and all his heads and cables went in the second. First time out, on a trip to Cleveland, Case Number 1 came through perfectly while Case Number 2 went on a tour of Europe! Although Case Number 2 eventually showed up in Cleveland, the photographer realized he had made a fatal mistake. Case Number 1 was worthless without Case Number 2 and vice versa. Therefore, Rule #1 is called "Stand-alone Packing." Each case you pack must have all the accessories you need to make its contents operable. The old saw about for lack of a nail... a country was lost is true about camera equipment, for lack of an adapter the picture was lost.

Knowing about luggage and its travels brings up a second point. If it's humanly possible, your cameras must travel with you as carry-on luggage... check your clothes, your lights, your wife, and your kids... but get your cameras on the plane! Along with my cameras I also carry on my tripod and some of the film I need. That way, I can shoot pictures when I arrive at my destination, no matter what happens to the checked baggage. I've learned the hard way about errant luggage that doesn't arrive with me. Therefore, the padding at the bottom of my camera bag is special. "What's so special?" you ask. Well, my padding is a clean T-shirt, along with a clean pair of socks and undershorts. That way, even if my outer clothes are "grunge city," I can feel human on a closer level. If you decide to follow my advice then let it be known that along with my "padding" I throw in a toothbrush and a comb... their weight is negligible and I hate the feeling of overcoats on my teeth.

Over the years, I've developed specific cases for each of my camera systems. 35mm, medium format and large format each has its own case. Some accessories are common to all the cases. Lens tissue, cable releases, meters, tools, and emergency kits are always needed, regardless of the camera's format. As I've become more involved with photography, I've collected a bunch of accessories in duplicate and in each camera case I try to fit a full set of accessories. That way I'm not forever transferring my essentials from case to case... always forgetting something vital. While duplicating meters is expensive, polarizers, cable releases, and jeweler's screwdrivers aren't so dear and can often be squeezed into a budget. If you must move equipment from case to case (or bag to bag) then it pays to organize things into ditty bags (see that tip for more info) so, at the very least, you won't leave out the one crucial accessory you need.

Tips on Setting Up a System

24 Know Your Film

Sometimes I laugh when I look at a neophyte photographer's film supply. Five different slide films, two or three color negative films and two or three black and white emulsions. *One roll of each!* With all those choices, it's pretty hard to know what to use. Consider also that a lot of picture-taking situations require multiple rolls of film and each film has specific characteristics that an accomplished photographer can exploit for controlled, repeatable results.

When I started to shoot pictures (I wouldn't dare to call them photographs) my mentor made it clear that I wasn't allowed to run willy nilly through the film forest. "Pick one film and learn it," that's what he would say. Only after *hundreds* of rolls of one film had been shot, would he let me try another. While the argument of exploiting all the different films is enticing, there is a lot to be said for a slower, more methodical approach. Under different conditions each film reacts differently and until you know the entire list of a film's strengths and weaknesses, you don't know the film. Some films reproduce colors differently with long exposures; you won't know that without trying it. Certain films yield excellent skin tones while others produce fabulous greens. Some films offer fine grain and others give you golf balls. Certain films produce very accurate colors while others add a color statement of their own to the photograph. Sometimes you want "Disneyland" and other times you want to be exact in your color rendition.

This is not easy stuff to learn and throwing more variables (different films) into your mental filing cabinet can make everything a confusing blur. Pick one slide, one color negative, and one black & white film when you start out. After a lot of shooting (you define a lot), add one more film to your arsenal and shoot a lot of it. In the long run you'll establish a mental data base that will be very complete. Now, I'm not suggesting this rule should never be broken (all rules are made for that) but it will put you on the road to a greater percentage of successful images.

25

© Steve Sint

Keep a Log

This tip is the biggest drag you can imagine. It will also do more to improve the quality of your photographs than many others. When you first start out shooting pictures try to keep a log (a small pocket notebook will do) of what your subjects are and what exposures you have used. THIS IS A PAIN! The good part is that after a short time you will become a better light meter than the one in your camera! With all of the automatic controls (some say simplifications) available in today's cameras, it's all too easy just to push the shutter button and move on to the next photo op. The problem is that while your camera knows what it has done, you haven't a clue. In the first place, picture taking becomes boring quickly. You are nothing but a button pusher. Also, when you learn something yourself, you get a good feeling of accomplishment and that's fun.

Even if you never open your log book after you've made your entries, the very act of writing the information down impresses it in your mind. If you use your log to its fullest potential, you'll sit down with it and go over the entries as you look at your photographs. That way you will begin to understand what you are doing and what you should change to improve your photographs.

Now for the good news. You don't have to keep your log forever! After a short while you'll understand what you are doing and, other than an occasional short note to yourself, you won't need the log as a helpmate. I might point out though that many of the world's great photographers have kept logs for years and, although they know the information inside out, they still find the written record helpful. How long you keep it is up to you but in the beginning it really helps... unless you have total recall.

26 Make a Card File

About 20 years ago I bought my first new car and on the day I took it home I added a new file to my filing cabinet. For the life of that car, whenever anything was done to it, the information was

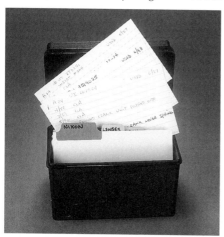

added to the file that I kept. This record proved to have advantages. After a short time I started to know what would break and *when* it would, too! My file gave me ammo at the dealership also. No one could tell me I had missed a service because I had a record of it all. Years later, when I sold the car, the file proved to the perspective owner that I had indeed taken care of it. My file worked so well that I made one for my camera equipment. It, too, has proven its worth over the years.

In a small plastic file card box I have a stack of 3-1/2 x 5" index cards. Each card represents a piece of equipment I own. In the file box there are dividers separating each camera system from the others. Each card has the type of equipment, the serial number, the date purchased, whether new or used, and whom I purchased it from. All this and any special notes are on the card's header.

Every time a piece of equipment is repaired, lubricated, or adjusted I make a note on its card. You'd be surprised at what you end up learning. Let me give you some examples: I use four identical medium format camera bodies and I try to rotate them through CLA (clean-lubricate-and-adjust) treatments with my repairman.

More than once I've discovered that a camera has been left out of the rotation. Some lenses go for ages without a whimper and some lenses need more work than a geriatric skateboarder. Also, repairmen have redone repairs when faced with proof that they've fixed the same thing two times in 3 months. Without the card file, I might not have remembered that the repair was made much less been able to prove it. I've even captured the ear of manufacturers' when a poor design repeatedly fails. The interesting thing here is that after 10 years of keeping my list I can tell to the week when a shutter or sync contact is going to fail. It doesn't prevent the failure but knowing when it's about to happen helps me stay cool when it does.

I'm sure someone (maybe even me!) could figure out some snappy computer program for their Mac that would keep all this info at a fingertip on a computer screen, but for now my $2.95 box works just fine.

27 Numbering Equipment

© Steve Sint

Most pros agonize over choosing a system. Not just cameras but strobes (AC or battery-powered), light stands, even tripods can be purchased with the system concept. Thinking of equipment as a system means eventually you'll own multiples of each piece and all your accessories within that system will work together. This is a must for the working pro so when equipment falters on a job, it can be easily swapped out of use. If one piece is being repaired, its accessories can be used with other units within the same system. If your photographic level is "serious" it pays to commit to building a system.

If you work at the system concept for a couple of years, things can get complicated. Right now my location strobe system contains four identical packs, a half dozen flash heads, and all the related cables. My battery strobe system also includes four packs and five heads and my wireless remote flash triggering system has

three transmitters and receivers in its group. When something breaks within a system there is almost always a back-up available. However, keeping track of what's broken can become a trick.

While organization helps (see "Make a Card File"), remembering which pack was too pooped to pop when on location is sometimes too hard for me to do. I guess I run out of memory. To sidestep this, I've taken to numbering all the packs, strobe heads, batteries (rechargeable types), and film backs within a given system. I use a permanent marker to add my initials and system number to my AC packs and heads. For items that are black, I write the same info on small, permanent labels. I find it easier to remember that pack #2 went down than serial #362478. As an added benefit, I make the labels big enough to read without my glasses. At this point in my life, I can't even see serial numbers!

© Steve Sint

28 Notching Backs and Bodies

Professional photographers often work with multiple 35mm cameras or medium format cameras with several interchangeable film magazines or backs. Black and white can be shot alongside of color, less time is wasted reloading film, and in the case of 35mm, different lenses can be used almost simultaneously. Problems arise though when one of your interchangeable backs or one of your 35mm bodies goes on the fritz. Which one is broken is the recurring question when you are looking at processed film that contains some messed up rolls. In my case, I use three 35mm cameras or at least three film backs on each assignment. For my peace of mind, I've devised a way to tell which film went through which body or back. This doesn't save the film I've already shot but it does make chasing down the gremlins much easier and helps prevent repetition of the blunder.

For lack of a better term, I call this procedure "notching" and all my 35mm cameras and film backs have undergone the operation. I leave one camera body or film back as is, and the others

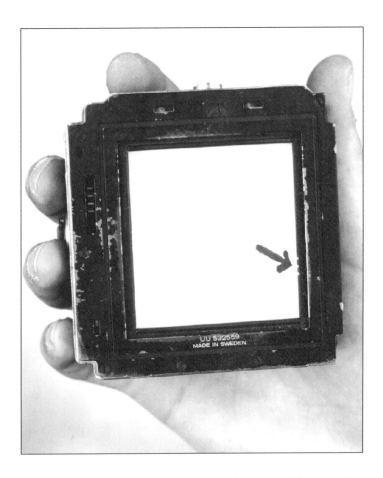

have a series of very small "V" shaped notches filed into the camera's film gate. Change the number of notches and/or where they are positioned on the film gate to differentiate each piece of equipment. Once this is done, each frame of film from that camera or back has notches visible on the processed film that has passed through it.

You can do this yourself or have it done by a competent repairman but in either case neatness is next to godliness. I use a small triangular jeweler's file (the important word here is small) and after I'm finished I touch up the shiny notches with matte black lacquer

to make sure I haven't gained any unwanted internal reflections off the bare metal. In the case of my 35mm cameras, I perform my "operation" with the shutter locked open on "T" (or "B" with a locking cable release.) While I file, I hold the camera so that the metal filings fall *out* of the camera and not into the shutter mechanism. I do the same for the film backs, but I don't have to be as careful because they don't contain a delicate shutter mechanism. If you are faint of heart, have a repairman do this for you. After all, doctors never work on their own families! Over the years, the ability to trace a gremlin to a specific piece of equipment has saved me many, many times. It can help you too!

© Steve Sint

29 The Hasselblad Cryptogram

While this tip is specific to Hasselblad cameras, it is so interesting that I just had to include it in this book. Every Hasselblad body and magazine has a code incorporated into its serial number that tells those in the know what year the piece of equipment was made. All older Hasselblad equipment has two letters before the serial number and that's where the code starts. See the illustration for tip #28 "Notching Backs and Bodies."

Victor Hasselblad wanted to know when a piece of equipment was made, so during his leadership all backs and cameras featured the code I'm about to divulge. Newer Hasselblad equipment also has a code which has been expanded but is still decipherable.

The following letters stand for Victor Hasselblad PICTURES and they represent the following digits:

V	H		P	I	C	T	U	R	E	S
1	2		3	4	5	6	7	8	9	0

Therefore, if you have magazine #RH 123456 (a fictitious number) that magazine was made in 19 (R=8) (H=2) or 1982.

There are some wrinkles in the system that I should mention. I have one magazine (and one body) in my system that are numbered "UUC" and I can only assume that the third digit represents a month: i.e.: (U=7) (U=7) (C=5) or 7/75. Furthermore, some late model equipment has serial numbers that have two digits followed by two letters, followed by more numbers: i.e.: 30**EV**20701 or 16**EI**10100. Even though numbers now precede the two letters, they (the letters) are still there. Judging by the newness of the particular camera and magazine I just cited, the letter code still holds. Maybe the first two digits represent a day or other production info. Just remember this so when the seller tells you it's "new" you might know better!

30 Numbering Polaroids

© Steve Sint

Polaroid® film is a remarkable material in its own right but for me its real claim to fame is the ability to test all aspects of a photograph before I commit it to traditional film. In a complicated, multi-light setup I use it to test individual lights; both alone and in relationship to other lights on the set. I test focus, depth of field, composition and finally, whether or not the camera system is working properly. Very often, my studio cart has a dozen Polaroids sitting on it before I am ready to load the "real film".

The problem is that often during all this Polaroiding, the phone rings, or I stop for lunch, or I want to see the effect of changes in one light in a set. When I'm ready to shoot my "final" I can't remember which Polaroid was which. To eliminate this lost in Polaroidville feeling, I number each Polaroid as I shoot it and make notes on what each recorded. Some of my friends also record on each Polaroid the time it was taken so that the test shots can be arranged in a chronological progression. This way they can go back along the road to final film and take another turnoff in the search for per-

fection. While this may not seem like much, nothing can be more frustrating than looking at a pile of Polaroids, choosing the one that says it the way you want it to, and not having a clue what the settings were that gave you the effect you're looking at.

The final Polaroid, the one just before "final film," is also very important. Very often my client wants to use it for image placement in a layout before they get the traditional film. And it's *no* fun when the Polaroid they used doesn't match the final image. To sidestep this problem, I nick the corner of my final Polaroid so that I always know which one it is. While my numbering system works well, the nicked edge ensures I don't shoot ten Polaroids but give out the ninth one.

© Steve Sint

31

Before and After Polaroids

Polaroid film is often used to check lighting, set-up, equipment, etc. before commiting an image to "real film." It gives a photographer peace of mind. But when you need to be absolutely certain

you have the shot, you should take before *and* after Polaroids. Here's the scoop: before you use your "real film" you shoot a Polaroid that you are happy with. After you have exposed the "real film" you shoot a second Polaroid. If the first Polaroid and the second Polaroid match, chances are good that when you shot the "real film" everything was working. While this test is surest with sheet film because there is no film transport variable to throw into the equation, I find it a comforting test when I shoot roll film. However, if you shoot Polaroid tests in 35mm (NPC® backs and all) and you use a different camera body for your Polaroid back than you do for your "real film," the second Polaroid (as a test) is not worth the paper it's printed on.

32

© Steve Sint

Money Lenses

Lens choice is a funny thing. Young photographers always want the widest or longest or fastest lens available. The trouble is that most photographs are shot with lenses that bracket a normal lens. When I work in 35mm, I carry lenses from 15mm to 420mm but if I had to choose only three it would be a 28mm, a 50mm, and a 105mm. Over the years I've realized that while I can take a "show-stopper" with an ultra wide or an ultra long lens, 98% of my photographs are taken with the three money lenses I mentioned earlier.

In olden times, the three lenses that 35mm photojournalists all carried were a 35mm wide, a 50mm normal, and a 90mm telephoto. These focal lengths didn't impress their optical signature on the picture and the viewer understood the photo because the picture angle appeared normal. In this era the 35mm rangefinder was king of the hill. With the advent of the 35mm SLR and as picture viewers became more sophisticated, the wide and telephoto parts of the troika were pushed outward. The three standards became a 28mm wide, a 50mm normal, and a 105mm tele. Standards have a way of changing and today (at last count) many pros consider money lenses to range from 20mm to 200mm. A good

part of this stretch are the 20-35mm and 80-200mm fast zooms available today that have great optical qualities.

The real lesson here is that you get much greater use from the lenses that closely surround your choice of a normal lens. In 35mm format photography, a 28mm or 105mm lens will see more action than a 15mm or 300mm. In medium format, a 50mm wide and a 150mm telephoto will give you more picture opportunities than a fisheye or 250mm lens. In 4 x 5 format, the money lenses are usually considered to be a 90mm wide, a 150mm normal, and a 210 or 300mm.

You can customize your choices to match a specific shooting style. If you primarily shoot interiors with a 4 x 5 view camera, then you might consider your money lenses to be all wides: 65mm, 75mm, and 90mm. On the other hand, if you use 35mm to shoot action sports you might find yourself on the long side of the spectrum with a 300mm treated like a normal, an 80-200mm (or a 100 or 180mm fixed focal length) to give you your wider view, and a 400 or 600mm when you've really got to reach. Before you buy both ends of the yardstick make sure you have the inches in between covered.

Hints For Holding the Camera Still

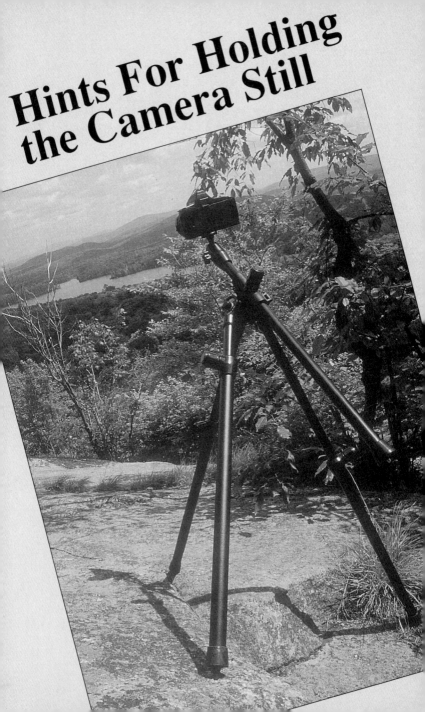

33

The 1/4"-20 Connection

Think about the common 1/4"-20 bolt for a second and you realize that in American photography this little thread design is just about everywhere. Bottoms of cameras, tops of tripods, light poles and accessories of all sorts sport male or female connectors with this thread. Interestingly, 1/4"-20 threading in the non-photographic world is just as prevalent connecting swing sets and holding on license plates. Because of this, sometimes a different type of 1/4"-20 connector becomes a much better solution in our photographic environment.

My favorite flash bracket came equipped with a plastic knobbed 1/4"-20 screw for attaching my camera to the bracket. All well and good, except the camera/bracket combo wouldn't sit flat on a table and, more importantly, with no flat bottom on the bracket I couldn't rest my unit on a ledge or table to squeeze off a time exposure when I was without my tripod. A quick trip to the local hardware store netted me a flathead 1/4"-20 bolt and a countersinking bit for my electric drill. The plastic knobbed original equipment was junked and the screw hole was reamed out with the countersink bit. When I attached my tripod quick release to the bracket with the flathead screw, the resulting connection gave my bracket a flat bottom... just what the photographer ordered.

Never willing to leave well enough alone, I decided that my bracket needed a touch more work and I drilled and tapped a 1/4"-20 hole into the bottom of my bracket. I tried to position this hole under the bracket's center of gravity so when I threaded the bracket-camera combo onto a tripod the thing would at least balance well. My next planned modification will include a quick release plate on the bracket's bottom, probably attached to the same 1/4"-20 hole I've already drilled and tapped.

Along the same lines, the Bogen® Swivel #3232 (Manfrotto) that rides on top of my monopod was blessed with a 1/4"-20 bolt and a plastic locking ring. Out with the plastic ring. The Bogen screw was replaced with a 1/4"-20 bolt and a lock washer from

my local hardware store. This idea was presented to me by Really Right Stuff. Because I use their quick release couplings and plates, I took their advice here and it was worth the trouble. My new connection is bulletproof and I don't have to worry about the plastic ring cracking before I do.

34 A String Monopod

© Steve Sint

Most photographers use monopods or tripods to steady their cameras and, in truth, even at fast shutter speeds, picture sharpness increases with steady support. The trouble is, tripods and monopods are often a drag to carry, especially if you are not planning to make long exposures. Did you know there is a camera-steadying device you can make for less than a buck that weighs almost nothing? To pique your interest even further, you can even stash it in your pocket. All you need is a 1/4"-20 eyebolt and 5 to 6 feet of nylon rope.

Tie one end of the rope to the eye of your bolt. Thread the bolt into your camera's tripod socket and you're all set. Get ready to steady things by raising the camera to your eye and stepping on the free end of the rope. As the rope gets taut you will have created (for lack of a better term) a rope monopod. You'll find that you can probably gain one or two shutter speeds in handholding ability once you have something to brace against, in this case the taut rope.

Putting the middle of the rope under your knee will probably work just as well if you have to do a low angle shot. The reason I recommend nylon rope is that a flame applied to the ends will melt the rope and keep it from unraveling. My monorope (ropepod?) has been with me for years and it's provided me with the extra steadiness I've needed on more than one occasion.

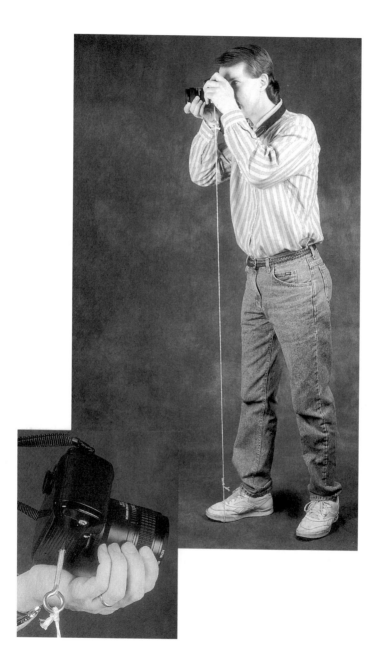

35 Use a Beanbag or a Wallet

Everyone has heard of resting the camera on a beanbag to ensure sharp pictures at slow shutter speeds. Most people even carry the beanbag empty to save weight while traveling (and fill it with something, anything, when they get there). But there are beanbag substitutes all around us. My favorite is my shoulder bag. Once I pull my 80-200mm lens and body out of my Domke® bag, it becomes a perfect rest for that heavy lens. I sort of hack a groove into its top with my hand, nestle the lens in and shoot away. What many people don't realize is that they carry camera resting devices with them all the time. There are literally dozens of times when you can find a flat surface to rest a camera on. All the flat surface needs is a little help.

For years I've photographed church interiors. You know, those quiet, beautiful places with light streaming in through stained glass windows. I like to shoot at f/8 but that requires a 2-4 second

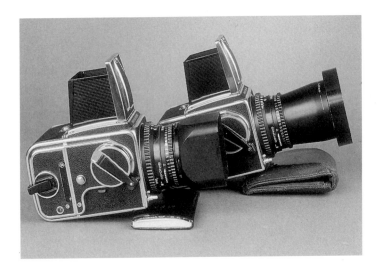

exposure and I don't want to set up the tripod. I start looking for a place to rest my camera. My first try is the ledge of the choir loft but it's often locked. Next, I try the center aisle... no flat surfaces there. Or are there? You can rest your camera on the floor but then you'll cut off the top of the altar and get a lot of unfocused aisle in the foreground. But you could use the floor if you could tip up the front of your camera just a bit, you know, maybe a 1/4 to 1/2 inch. Hey! My wallet is about 1/2 inch thick, my pocket calendar is about 1/4 inch thick and I always have a book of matches with me... that's a wedge! Over the years I've used these three items as camera "rests" dozens of times, sometimes at the front of the camera and sometimes at the rear. If you want to tip the camera up, you raise the lens, tip it down by putting your "rest" at the rear. The idea is *so* simple. The thing to remember is that you have the accessories in your pocket.

36

© Steve Sint

Weighting Your Tripod

Tripods are weird animals. If the tripod is good, it's usually heavy. If it's heavy, you usually don't want to drag it along with you. While most pros wouldn't be caught dead without a tripod, most beginners think of them as something that doesn't fit into a free-wheeling style. Be it tripod, monopod, or beanbag, some steadying device is helpful most of the time. After all, when you handhold a camera, you should realize what is working to hold the camera still. The human body is a jumble of twitching muscles and nerves. If you add to this the fact that all human bodies have a constantly working pump within and two lungs that are inflating and deflating, it becomes easy to see that the quivering mass of protoplasm we call our body isn't a very steady support.

You can get around the strain of lugging a heavy tripod if you use what's around you. If you use a lightweight tripod, it usually doesn't have the mass to dampen the vibrations caused by an average camera. If, however, you buy a well-built, lightweight tripod,

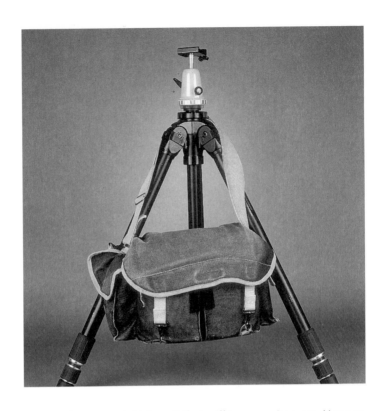

you can hang a weight from it that will increase its mass. You can use a mesh ditty bag to hold rocks or hang canned food from your tripod as a steadying device. Or you can do as I do and hang your camera bag over your tripod for the added mass you need. Not only will it make your tripod like Gibraltar, it'll get the bag's weight off your shoulder and keep it off the wet and soggy ground. Both of these are worthwhile fringe benefits.

37

Keep Your Tripod on a Leash

I take my tripod everywhere. My favorite, a short heavyweight Gitzo® with leg spreaders, is very sturdy and VERY heavy. I can't slip it into a suitcase (it's too big) and it doesn't fit in my camera bag (it's still too big). I carry it separately and to do that I've rigged a sling so that I can throw it on my shoulder and hit the road... so to speak.

The surprise is that I didn't get my sling at the local photo shop. Instead, I found my sling hanging on a rack at a pet store. You see,

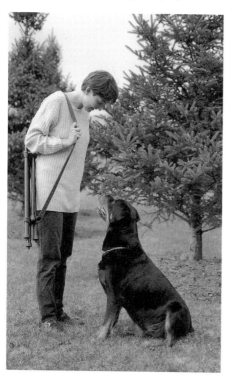

my sling is a heavy duty, nylon dog leash and collar. The "collar" is buckled around my tripod's legs (near the tripod feet). The leash is the sling, and the handle is used to form a slip knot that I place over the tripod head. To make the handle into a "slip knot type loop," I pull the length of the leash partially through the loop formed by the handle and pass the resulting loop over and around the top of the tripod.

While I truly love my dog leash sling, it does have a few limitations. The smooth nylon leash slips off the shoulder of my nylon parka. That is truly a drag. Walk a few steps... hike the sliding sling back up onto my shoulder... walk a few more steps... hike the sliding sling back up onto my shoulder... etc., etc. I wouldn't even recommend this as a tip if it weren't for some rubberizing gook from my local hardware store. The product is intended to be used to coat the handles of screwdrivers and pliers but I painted some on my sling and it worked well. If you can't find the rubber stuff, I have two suggestions. You can buy a leather leash for more grip on your shoulder or you can get a non-slip camera strap shoulder pad and thread it onto your leash/sling. All this effort is worthwhile because the tripod sling is so easy to use. To sweeten the whole pot, when you leave your tripod at home, you can use the leash to walk your dog!

38

© Steve Sint

The Water Tripod Test

With the mirror of an SLR slamming around and a shutter banging open and closed, it's really difficult to know if your tripod is really holding your camera still. Well, a shot glass of water can help you figure it out (or if you aren't so daring use a jar with a lid.)

To do this, mount your camera on a tripod and tape a small water glass to the top of your camera. Pour some water (<u>very, very</u> carefully now) into the glass (put on the lid if you're using a jar) and you're ready to go. While you may not be able to tell if your camera is shaking when you release the shutter, you'll be able to detect the slightest movement by watching the water. Any ripples and you've got problems. Try this test at the shortest extension, the longest extension, and with the center column up and down. Try using a cable release and locking up the mirror to see the effects in all these situations.

Some people have questioned this test by saying that I wouldn't be able to tell whether the ripples (vibrations) happen before or

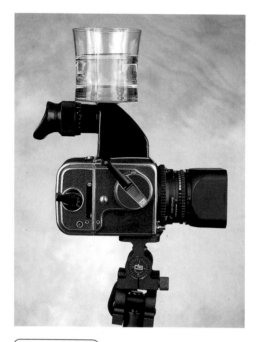

after the picture is taken. After all if the shutter's closing action çauses the shakes... well, who cares? To rule out post-picture rippling of the water, I do my testing at longish shutter speeds. That way as my shutter opens I can see if the water is moving.

39

© Steve Sint

Make a Repeatable Index for a Tripod Head

Imagine a situation: You're standing on a ladder, six feet off the ground, looking through the viewfinder of a camera mounted on a ten foot tripod. Just before you shoot, you decide to add a gelatin filter to your lens and change the f/stop. What to do... what to do? Climb down off the ladder, put the ladder at the front of the camera, climb back up the ladder, put on the filter and change the f/stop, climb back down off the ladder, put the ladder back near the camera's viewfinder, climb back up the ladder and release the shutter. Whew, after all that work, I don't want the picture anyway! There's a way around this up and down style that's as easy as a piece of tape and a fine point pen, if you have the right tripod head.

Back to the ladder that's six feet off the ground. One way to change the f/stop or add a filter is by spinning the camera around, making the change and then spinning the camera back towards the scene. All this is made possible by the rotating feature on most tripod heads. If you're working with a view camera however, when you set the lens to take the picture (by closing and cocking the shutter) you can no longer see through the camera to realign it correctly. Thankfully, this problem has an easy fix. When I first set up my rig, I put a small piece of tape on two parts of my tripod head as a first step. One piece is on the part of the tripod head that moves when you rotate the camera. The second piece is alongside the first on the part of the tripod head that remains stationary when you rotate the camera. I draw a line with the fine marker that crosses both pieces of tape. Once that's done, I can rotate the camera all I want. As long as I align the two lines, I can get back to my starting point.

40 Modifying a Kirk Bracket

© Steve Sint

Probably one of the most important "money lenses" for professional Nikon shooters is the Nikkor 80-200mm f/2.8 zoom. This lens, which is the size of a big thermos, is fast and sharp. It also has an interesting history. Before Nikon introduced this lens, they questioned numerous pros about whether or not the lens should have a built-in tripod socket. All of the pros queried said this lens was a hand-held tool and a tripod mounting block wasn't necessary. Nikon introduced the lens without the mounting block and then the photographic press took Nikon to task for not including it. Whether Nikon asked the wrong photographers or should have ignored the responses is moot. The lens doesn't have a tripod mounting block AND it needs one.

This lens is so popular that four manufacturers that I know of have designed tripod couplings for it. Although they all seem to think they built a better mouse trap, I'm not sure how many mice

there are to catch. Be that as it may, I use a Kirk Bracket™ on my 80-200 but first I made some modifications.

The Kirk Bracket has an aluminum bar that extends from the camera body to a ring that fits around the front of the lens. On the bar's bottom are three tripod holes (tapped 1/4"-20) and a dovetail plate designed to fit an Arca-Swiss® quick release tripod coupling. Kirk supplies the bracket with two wing screws that pass through its bottom and thread into the camera body and into the bracket's ring that circles the front of the lens. Since these wing screws kept catching on everything (straps, cases, etc.) when I first used my bracket, they had to go. I replaced them with 1/4"-20 round head screws of approximately the same length. I removed the threads from the screw that went into the camera body, leaving only enough on the end to grip the camera (just like Kirk's wing screw). This modification made the bracket much easier to pack and carry. Finally, I drilled 2 holes through the bracket's bottom bar so I could attach a shoulder strap to the bracket. This takes the weight off the camera's strap lugs. To make the hole/strap combo work smoothly I opened up the edges of my holes with a bigger drill bit. My 80-200 with bracket now rides horizontally at my side ready for use and there's no weight on the camera's strap lugs. However, my shoulder still feels the weight. Oh well, fast lenses weigh a lot.

Shooting Tips, Tricks and Hints

41

© Steve Sint

Filling the Frame or Leaving Air

Whether you fill the frame or leave "air" around your subject depends partially on what format you are shooting. When I first started taking pictures in 35mm, the most frequent criticism I received was that I didn't fill the frame. "Use every square millimeter," was the motto. Many photographers, myself included, even went so far as to file out their 35mm negative carriers so that they could print every sacred grain of silver. "Crop" was considered a very dirty word... the purity of the image and all that.

Imagine my surprise when I graduated to 2-1/4 square. Now I was no longer shooting the full frame but was planning to crop my final image to a vertical or horizontal. Later still, under the hood of a view camera, I realized that I was now faced with an embarrassment of riches... more square inches of film than I needed. After working with 4 x 5 (and 8 x 10) for some time, I realized another thing. The marks from the processing clips ruined the image if I tried to wring every square inch out of the film. Actually, with sheet film, I prefer to think of the 1/4 to 1/2 inch of film around the edges as dead space. When you leave this area free, your photo is said to have a lot of "air."

Air can be important in 35mm as well. If you're planning on producing 8 x 10" prints (or any permutation thereof), you should consider the 1/8 inch to the left and right of your frame as dead space. While the idea of using the full frame has a romantic appeal, it's best to remember that the final image is what is important, not how well you filed out a negative carrier.

42

The Right Time To Shoot

I know a photographer who got a plum assignment. While working for a major airline, he and his crew flew to the Bahamas and each day at sunset he went up in a helicopter. From this perch he

shot photos of the airline's jets passing in front of the setting sun. You've all seen the photos. Funny thing is that although he was paid for a full day, everyday, all the photos were done in the late afternoon around sunset.

While we may all wish we were the photographer on that assignment, there's a lot to be said for when he did his shooting. I shoot scenics in the early morning and the late afternoon. Once the sun has climbed up into the sky, the quality of the light is (how should I term this?) YUCKY! Shadows are harsh, black and inky, under a noonday sun. When the sun is low in the sky, the light has a warmer quality and the shadows are longer. They can even become design elements in your pictures.

Oddly enough, I don't find early light as rewarding as late afternoon sunlight. Maybe it's because in the morning the daylight is moving towards its "yucky" stage. If you don't get what you want in the early morning, you have nothing to look forward to but bad light. In the late afternoon, however, if you didn't get the shot you wanted, you can often grab victory from the edge of disaster by turning around and shooting a last light scene. Then you can tell everyone that you planned it that way all along.

43 Work with a Limited Palette

© Steve Sint

Great color photography is no easy feat. In addition to the subtleties of shape and texture used in black and white work, you must throw color into the mix. What may be an inoffensive gray blob in a black and white photograph can be a bright orange spot (a flower for example) that destroys an otherwise beautiful composition. Color value calls attention to any item in a photograph. One way to get around the confusion of multiple colors and their intensities is to limit the number of colors you use.

Some of the most memorable color photographs ever taken use just a spot of a *single* bright color. You might have seen these in photo anthologies or advertisements. Many people remember a

scene filled with gray steps, people in dark raincoats using black umbrellas, and one single red umbrella. The red umbrella screamed off the page. If there had been 10 or 12 multicolored umbrellas around the red one, you can be sure that the red umbrella would have had less impact.

Start to look for scenes with a limited palette yourself. Yellow street lines or taxicabs on a wet day come to mind. Green pastures with a white picket fence also fit this scenario. While you can train yourself to "find" these scenes, you can also create them yourself. Out of focus green leaves on trees are a perfect background for making a colorful subject POP out. You might consider dressing two (or more) portrait subjects in the same tone. Maybe everyone is dressed in shades of blue (such as jeans) or earth tones. While a rainbow is beautiful to behold, sometimes you don't want something blue, something orange, something yellow, something purple, etc., all in the same picture.

44

© Steve Sint

Basic Framing

Sadly, many photographs would be improved if a 35mm focusing aid were superimposed over the picture. This is because today's photographers are blessed with autofocus cameras and it is all too easy to lift the camera to your eye, center the subject, and push the button. In this rush to take the picture many photographers have forgotten that framing and focusing are two different operations that accomplish different things. While focusing is a mechanical act that assures the camera and lens are set correctly for a sharp picture, framing is an aesthetic act in which the photographer decides what the viewer will see.

In the days of Speed Graphics with coupled rangefinders, the windows for viewing and focusing were separate, and the photographer always followed a three-step process: focus, frame, shoot. Now with autofocus and other focusing aids, the art of framing is withering on the vine. This is too bad because the really memorable photos are always the ones in which framing was given some thought. It is the photographer's place to control what fits into the frame so that the image's message is clear.

Basic framing for people pictures can be broken down into two types: whether the photograph is a head shot or a full-length portrait and whether the format is vertical or horizontal. For head shots, one or two subjects always fit better into a vertical format and four or more people usually fit better into a horizontal frame. A picture with three subjects can go either way, and whether you shoot vertically or horizontally depends on how much the subjects weigh (their width). In a full-length situation, one, two, three, or four subjects all fit into a vertical more readily than they fit into a horizontal, and six or more folks always seem to fit better horizontally. Five subjects, full length, once again fit into neverland, neither fish nor fowl. It's always a judgment call.

Do these rules mean you should never do a single person as a horizontal? Of course not. These rules are just approximations to be used in most cases but thrown away as soon as the creative

73

urge moves you. Use the rule most of the time and your subjects will be happy. Throw it out occasionally when you're making a statement and everybody comes out a winner.

45 Shoot Kids at Eye Level

© Steve Sint

Don't be lazy. There are too many kid pictures already in which the child is portrayed with a gigantic head and teenie, weenie feet. That's because while grown-ups love shooting pictures of kids, they won't get down low and shoot the photograph at eye level with the child. Instead, family albums are graced with balloon-headed kids that look, well, weird. It's a simple rule of portraiture: most head shots should be shot with the camera at eye level to the subject. This camera position captures the subject without distortion. So why are photographs of kids any different? First, it's laziness. Next, most adults don't want to get down in the dirt with

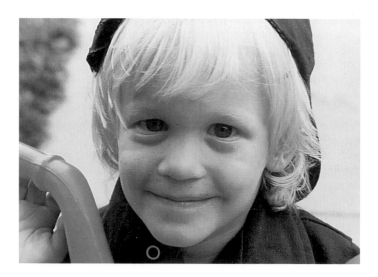

a sticky, messy, two year old. That's a pity because the world of children presents very interesting views (aside from seeing gum stuck under the table.)

If you use a long lens to photograph kids, you don't have to get down as low as you do with a shorter focal length. This is because as you back away from the child (for good framing with the longer lens) the downward tilt of the camera becomes less. When you're 30 feet away and standing erect, you might only have to tilt the camera down a few degrees to get the shot. With a shorter lens, hence a shorter camera to subject distance, you have to tilt the camera down more until eventually, with a wide angle lens, you are pointing the camera straight down! Once you're at this point you have a balloon-headed child in your frame.

Many great, intimate portraits of children can be done with a wide angle lens. Children aren't as camera conscious as adults and, although they may put a sticky finger on your lens, they quickly forget that the camera is there and just act natural. Be that as it may, when you shoot kid pics, shoot them from the child's eye level.

46 Do a Double Exposure

© Steve Sint

Like the triple axel (so called because it was first done by an 1890's figure skater named Axel) of figure skaters, double (and triple) exposures in the photo world always draw oohs and ahhs from the crowd. Luckily, they are very easy to do... under certain circumstances. But before you run off to "do the double," some thinking is in order. If you are trying to overlap one image with another, you have to cut your exposure for each image by 1/2 to 1 f/stop. This is tricky because a light background on either image will blow the detail out of the other image that you are super imposing. If, however, you work against a black background, the only area of the film that is exposed is where the first image lies. All the other "black empty space" is free for an additional image(s).

There are two easy ways to avoid exposing the film all over the frame when you make your first exposure. First, you can work against a black background and put your subjects far enough in front of the black background so no extraneous light falls on the background. You can use a roll of black seamless paper, a black velvet curtain or a black posing drape. If you side light the two different subjects from opposite sides for each exposure, their images can blend together nicely. An example of this technique appeared on a cover of *Time* magazine—President Bush was the subject and appeared to be two-faced. Double exposures are not necessarily flattering.

The second way to black out part of the frame is to use a mask in front of the lens. Don't get scared by the idea of using a mask. What is a mask anyway? A mask is something (preferably black) that is held in front of the lens during exposure, for instance, a

piece of black card. Here's the technique: You frame your first subject and then put the mask over the lens so that it blocks out most of the rest of the frame. To really see the effect of the mask you MUST STOP DOWN TO THE TAKING APERTURE. Large f/stops give your mask a soft edge and small f/stops create a harder edge to the mask's cutoff. Make the first exposure and then re-cock the shutter without advancing the film. Most cameras have a provision for this. Now, reverse the mask you are using and make a second exposure on the unexposed part of the frame. The mask blocks the area that contains the first exposure, thereby saving it.

These types of double exposures are great fun. They enable you to include serious and happy faces of the same person in the same photograph. With some careful mask placement you can have the same person on both sides of a frame... sort of like the Double Mint™ twins. Expect the oohs and aahs. People are always impressed when you "do the double".

47 Prefocus For Fast Candids

© Steve Sint

Young assistants who watch me shoot candid photos with a 2-1/4 square camera often tell me that I am quicker than photographers who use a 35mm camera with autofocus. How is this possible? Am I sacrificing focus, exposure, and composition for speed? Not really. The trick is to visualize where you're going to take the picture and what camera settings will be required.

After a little practice you can find one or two distances that produce good results in a variety of circumstances with certain lenses. Let me give you an example: If you put a 50mm wide angle lens on a 2-1/4 square camera (the equivalent of a 28mm wide angle on a 35mm camera) you'll soon realize that full-length candid photos of people require you to be about 10 feet from the subject. Equally true, bust length pictures of small groups of people are framed best from about 5 feet away. Knowing this, I can preset my focus distance for a particular picture and walk up to my sub-

jects until I reach the distance I've already set the camera for. Once I'm there (at the preset distance) it is simply a matter of raising the camera to my eye and pushing the shutter button. No need to twirl through the entire focus range - it has already been done. This works even better with on-camera flash or in light bright enough for a smaller f/stop. The extra depth of field adds room for error. This isn't a new trick; for years, press photographers toting 4 x 5 press cameras relied on prefocusing for greater shooting speed.

This is still a valid technique today in this world of autofocus. Very often, autofocus cameras need a few extra milliseconds to set the correct focus. Even worse, sometimes autofocus cameras miss the subject and spend a few seconds searching for correct focus. During those agonizing moments many great candid photographs melt into the surroundings (smiles fade, heads turn, hands block faces) all while you're waiting on your electronic marvel!

Also, time passes from the instant you push the button until the exposure is made. The difference between these two occurrences can be called a time parallax. The more electronic or physical events that must occur before your picture is captured increase the odds of missing the opportunity. When you set a modern flash unit to "red-eye reduction mode" and it flashes 20 times before you can release the shutter, you are extending your camera's time parallax. Sometimes the only thing that red-eye reduction reduces is the number of great pictures you get.

48

© Steve Sint

Follow the Sun

You've all seen the "skyline at sunset" shot. The buildings glow a soft warm orange, the sky is a deep purple, the feeling that "all's well with the world" fills your being. These photographs are fun and rewarding to take but getting them sometimes is just dumb luck. You happen to be in the right spot, at the right time, with the right camera/lens/tripod combo. With a little "preproduction" you can predict where the right spot will be and when. Now all you'll

have to do is remember to bring the camera! To capture buildings glistening in the sunlight you must realize an important point: you aren't just photographing the buildings, you are photographing the reflection of the sun and the sky in the buildings! To get a perfect reflection you've got to be in the right spot. Finding the right spot is the trick. Let's go to a pool hall for a minute. Sometimes in the game of pool a player does a thing called a bank shot. The ball hits a cushion and ricochets off in another direction. Interestingly, the angle at which the ball hits the cushion is the same angle at which it ricochets off. In photography this phenomenon is called "Angle of Incidence Equals Angle of Reflection." If you know which way the building faces and where the sun will set, you can figure out (with a map and a protractor) where you have to be to capture the perfect reflection. It's easy to see which way a building faces, but how can you find out where the sun sets every day, all over the world? Here's how.

I invested a quarter and called the Hayden Planetarium in New York. Their research department sent (actually faxed) me a list of where the sun sets every day of the year in New York City (which was the skyline I wanted to shoot). The Hayden Planetarium (or the one near you) has listings for all the cities of the world; it's a simple computer program. The planetarium printout listed sunsets in degrees from north. Next, I got a map of New York and a 360° clear plastic, circular protractor. When I placed the center of the protractor on the Empire State Building and aligned 0° with north I could read where the sun would set all year! When I drew a line on my map from the sun's setting position I could see where the sun was in relation to the skyline and then by applying the "Angle of Incidence Equals Angle of Reflection" rule I could figure out where I would have to be to get the reflection I wanted. So much for dumb luck!

Now for the second part of our "beautiful skyline" photograph. Every time I cross the Hudson River to set up for my skyline caper there are always a few other photographers there too. The sun slowly sinks in the sky, and when the big red ball is reflected in a building they all shoot like mad. Me?... I wait. Why? When the big red ball is reflected in a building, the contrast range is too wide to be recorded on the film. If I expose for the big red ball, the buildings don't all sparkle. If I expose for the skyline, the big red ball is hopelessly overexposed. That's why I wait. Two minutes (or so) after the sun dips

below the horizon the entire sky turns into a reddish orange sheet and all the buildings reflect the entire sky's glow. Additionally, the sky's reflection is less bright than the sun's reflection so my film can record the entire scene from reflection to skyline.

If you photograph one skyline a lot it might pay to make a shooting map which has places and dates penciled in. In my studio, I have a New York map that shows me where to stand on which day to get the maximum reflection. There's a story about an older *Life* magazine photographer who had a list for many of the world's landmarks with where to stand on which day. You can do the same thing for yourself. In the pro photo biz this is called "preproduction."

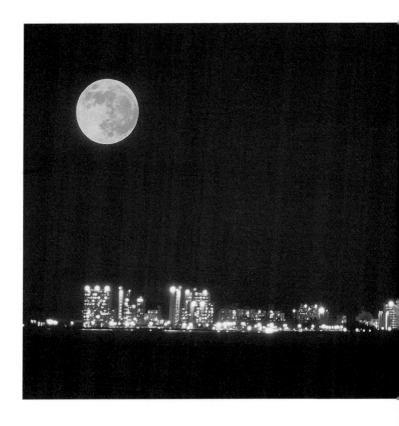

49 Shoot the Moon

We've all seen great photographs of the full moon hovering over a cityscape. Sorry to burst any bubbles but usually that photograph is a double exposure or a composite (the difference is whether it's done in the camera or in darkroom). This is because the contrast range between a nighttime cityscape and the moon is just too large for the film to handle. Expose for the cityscape and the moon is a white (very white) circle. Expose for the detail in the moon and the cityscape is hopelessly underexposed. How do I know this? Simple. A full moon is a

subject that is lit by direct sunlight. This means that the "f/16 rule" holds for exposure: a subject lit frontally by the sun requires an exposure of f/16 at a shutter speed of 1/ISO. Most skyline photographs at dusk (or at night) require a much longer exposure. However, there is an easy way to get the moon into your cityscape, correctly exposed... AND placed anywhere you want it.

When you see a full moon on a clear night get out your long lens, camera, and tripod. Forget about the cityscape for a moment. What you're going to do is photograph a roll (or more) of the moon placed in the frame where you want it. Then, rewind the roll (leaving the leader out of the cassette), make a note of the moon's position and save the roll of film. I keep my moon rolls in a plastic bag in the freezer. When I go to shoot a cityscape, I thaw the moon roll, load it in my camera and shoot. My

processed slides are a double exposure of the moon and the city-scape... sometimes shot *weeks* apart. Photographers who use this technique follow some special rules. The moon (even a full one) isn't always in a perfectly clear sky. With that in mind, when it's perfect, they shoot a lot of moon exposures. They make hay while the moon shines.... so to speak. To keep things simple, it pays to use a whole roll on one moon position, if you're on a tight budget use shorter rolls. However, a perfect moon is worth some variation so try it positioned for verticals, horizontals, low in the frame, centered, or anywhere else that might be appropriate.

Keep in mind that when you reload the roll, you have to start it at the same point so the frames align and the moon is in the right place. This can be accomplished with a fine point marker. When you originally load the moon roll, and have it firmly attached to the take-up spool, draw a little tick mark on the film that aligns with a certain point within your camera. Just as you noted the moon's position, make a note as to where the starting point is within your camera. If you forget, you probably won't be happy with the results.

© Steve Sint

50 Prefocus on a Spot

It happens all the time: the bride is walking down the aisle and Aunt Ruthie is sawing away at her focus ring trying to get the action frozen and in focus for all posterity. She focuses, the bride keeps walking, she refocuses, the bride keeps walking, she refocuses and the bride passes her by! Same thing different situation: young Jon hits his first extra base hit; he's running towards first base; Dad focuses, Jon keeps running, Dad refocuses, Jon is still running, Dad refocuses, Jon is safe but no picture for Dad! Do you ever wonder how sports photographers and other photo journalists effortlessly lift the camera to their eye, snap off a frame and come back with the picture IN FOCUS?

It's very easy once you know the secret. Pros always look for a

landmark on which to focus. When the subject passes that spot, they push the shutter button and get their picture. It's that easy. Let's go back to the church and the bride walking down the aisle. This time Aunt Ruthie focuses her camera on the lady in the purple dress sitting in the aisle seat six pews up the aisle. Now, Aunt Ruthie waits. Here comes the bride. The bride passes the lady in purple and as she does Aunt Ruthie pushes her shutter button. Aunt Ruthie gets a sharp photograph to show to the bridge club. In the other example, Jon's Dad focuses on first base. As Jon extends himself to cross the base, Dad snaps off his frame just as Jon's foot hits the bag. A puff of dust and there is a great picture for Dad's office!

Depending on how fast your subject is moving, this technique may require a little practice to learn how much to "lead" quicker subjects. Not only is the subject's speed part of the equation but the camera's time parallax comes into play. When you push the button on a manual SLR, many things happen before the picture is actually taken. The mirror flips up, the auto diaphragm stops down and the shutter has to open. Even more happens on newer auto-exposure cameras. While all this stuff happens in milliseconds, the delay still must to be taken into account. The faster the subject is moving the more these milliseconds become a factor. A car traveling at 60 mph is moving at 88 feet per second. If your camera's time parallax is 1/10 of a second, the car has moved 8.8 feet! Like everything, practice of this technique makes perfect. But it's a great feeling when you pull it off.

Exposure Tips, Tricks and Hints

51 The f/16 Rule

Before there were expensive, sensitive light meters, how did technicians figure out what the ASA (they didn't use the term ISO then) of a film was? One way was to choose a consistent light source and use it to quantify the diferences in one film's speed compared to another's. As luck would have it, the sun is very consistent between 10 am and 2 pm under a clear sky.

It turns out that the proper exposure for a subject (with any film) that is frontally lit by the sun between 10 am and 2 pm is f/16 at a shutter speed that is 1/ISO. For example if you are photographing a subject (in full frontal sun) with a film having an ISO of 125 then your exposure is f/16 at 1/125 of a second. This is the quickest way to test light meters that I know of.

The f/16 rule is more than a light meter test. If your subject is side lit (same sun, same time, etc.) you open up one f/stop from the frontally lit exposure. If your principal subject is back lit (but under open sky), open up 2 f/stops from the frontal exposure. If you are on the beach or in snow with a lot of light kicking back off the ground, close down 1 stop from the regular frontal, side, or backlight exposures. With a little thought a whole series of exposure information can be worked out from the f/16 rule, plus it's a great test of light meters.

52 F/stop vs. T/stop

F/stops don't really exist. Well, they really do exist, but only in a pure mathematical sense. If you divide the f/number into the focal length of the lens you will get a number that is the diameter of the exit pupil of the lens. A 50mm f/2 lens has a 25mm rear aperture

(50/2=25). A 100mm f/2 lens has a rear exit pupil of 50mm. That's the way it works in the mathematical world. In the real world things are different. Different lens coatings absorb more or less light. A greater number of elements pass less light than fewer elements. Internal baffles in a lens cause more or less light to make it through. Luckily, most times in the real world we can work with the close approximations that f/stops present to us... but not always.

Cinematographers use lenses that aren't calibrated in f/stops. They use lenses that are calibrated in "T" stops. While an f/stop is a mathematical possibility, a "T" stop is a measurement of the actual light *transmitted* by the lens. Why do cine guys get the real McCoy while "still" guys get stuck with woulda, coulda, shoulda? In the first place, cinematographers aren't exposing just one frame of film every time they push the button....they're exposing many. Secondly, cine shooters often have many more (and higher) production costs when compared to still photographers. Lastly, cine lenses are more expensive than comparable still lenses so the manufacturers can justify individual lens testing.

Does this mean that still photographers can never get the "T" stop information they really need? Well, the answer is yes and no. You can take a still lens to a reputable repair company and they might be able to calibrate it in "T" stops. If you live in or near a large city sometimes there are cine rental and repair facilities that can do the job for you. Or, you can run some tests yourself to give you a ball park idea of different lens' transmission capabilities. Take your most complex, fixed aperture zoom and make manual settings comparison photos with a single focal length lens. Remember to set the zoom to the same focal length. Are the processed slides comparable? Most times you'll find the zoom lens transmits a little less light than the fixed focal length lens does. In the still photography world, a tenth of an f/stop difference doesn't mean much, your processing or shutter can easily be off that much. A half or third f/stop, however, is noticeable. With today's automatic cameras, many times slight transmission differences are accounted for by the auto exposure system. The trouble is that as you become a more advanced photographer you start to shoot in manual mode and, worse still, pro grade, medium and large format cameras are usually non-automatic. That's when it pays to remember your tests. It's nice to know that with a specific lens when the meter says f/8 you should set the camera to f/6.3!

Using Your Hand as a Gray Card

Sometimes it's easy to forget that light meters aren't intelligent beings that operate under free will. All reflected meters will only give you the amount of exposure needed *to render the thing it is aimed at as middle gray.* Aim your reflected meter at a black cat in a coal bin and it will offer an exposure that will overexpose the cat and coal to a MIDDLE GRAY. Aim your reflected meter at a white rabbit in the snow and it will offer an exposure that will underexpose the rabbit, and snow to a MIDDLE GRAY. Pros often

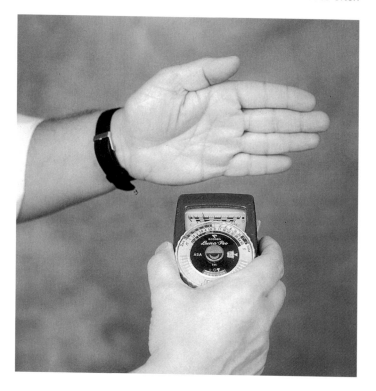

get around this by using an incident meter that reads the light falling on the subject instead of the light reflecting off it. Whether black cat or white rabbit, the light falling on either is not dependent on their reflectance. Trouble is, meters in cameras are reflected meters and you can't make one into an incident meter easily. A reflected light meter pointed at a gray card, however, will give the exact same exposure as an incident meter. It's this bit of information that we're going to exploit.

We can always point our reflected light meter at a gray card and then use that exposure, but that means we always have to be carrying a gray card along with us. That's not always possible, but we always have our hands with us! When I took a light reading of my hand, I discovered that it called for an exposure one stop less than my meter pointed at an 18% gray card. This is totally consistent (as long as my hand is clean). By taking a reading off my hand and opening up one stop I have the same light reading as if I had pointed my meter at 18% gray. It is also the same reading I would get if I took a reading with an incident meter. The best thing about it is my hand is with me all the time! If you want to try this handy exposure technique invest a couple of bucks in a Kodak® Gray Card and use your meter to compare it to your palm's reflectance. Once you know the exposure compensation for your palm to 18% gray, you'll always have an incident exposure meter at your fingertips... literally. By the way, I specifically recommend your palm because it doesn't get sunburned like the back of your hand does. You've got to keep your "meter" consistent!

54 The Zone System at the Subject Level

© Steve Sint

Most advanced photographers are familiar with the zone system. By using it, a photographer can control subject contrast by varying exposure and development. You can decrease negative contrast by overexposing the negative when you shoot it and then underdeveloping it. What you are doing by overexposing the negative

in your camera is exposing the shadow areas onto the film. When you underdevelop the negative, you are preventing the highlights from getting too dense. Thus, you are lowering the contrast of the negative. But what can you do if you can't custom develop the film?

For years I've had to shoot pictures of black cameras against white backgrounds. Talk about a high-contrast nightmare. Expose for the overall scene and the cameras look like a black hole. Expose the scene so that the black camera's details are "open" and you overexpose the white background to the point of creating image-degrading flare. If I could custom develop my film everything would be OK, but I can't. My solution was to apply the zone system to my subject and forget about exposure and development.

Instead of putting the black cameras on a white background I put them on a middle gray one. Then I overexposed the black camera to maintain the detail in it. Guess what happened? The gray background was overexposed to the point that it was white. The only thing remaining was to tell my lab that the background was white and they should print accordingly (they never knew the difference). My black cameras showed full detail and... there was no flare!

While you can often control contrast through exposure and development in black and white photography it is not really possible in color work. This is where my gray/ white background switching ploy really shines. In fact one art director I know told me no one was better at shooting a black camera on a white background than me and he couldn't understand how I did it. Maybe someday I'll tell him that the background I use is gray, not white!

Just in case some of you think you'll never shoot a black camera on a white background, remember your neighbors might want a picture of their black cat. Put the cat on a gray background and overexpose away; your neighbors will love the photos!

55 Feathering Exposure

© Steve Sint

Certain films have safety margins built into them. If you are shooting black and white and/or color negative material you can overexpose a little, and no one will be the wiser. In fact, many portrait pros constantly rate their Kodak VPS Film (normally ISO 160) at ISO 100 or 125. Many pros (and advanced amateurs) religiously rate their Tri X film (normally ISO 400) at ISO 320 or even 200. Before you feign shock at halving the ISO, please realize that a change from ISO 400 to ISO 200 only represents 1 f/stop more exposure, and with negative film that isn't much.

If you shoot transparency film (slides), the opposite is true. If you overexpose slide film, the resulting picture becomes hopelessly washed out. As you underexpose slide film, the colors become richer. For this reason many pros rate their slide films at a slightly higher ISO, such as ISO 125 for ISO 100 film. (You don't have the embarrassment of riches that you do when you incorrectly expose color negative film, however.) All of this should be based on your own testing. As an example of how you can be misled down the primrose path, Fuji Film's Velvia™ (slide film) is rated at ISO 50 by Fuji but most pros set their meters to ISO 32 or ISO 40 when shooting it. This is the exact opposite of what I just suggested, but as far as I know, it is only true in this one instance.

There are other ways of feathering your exposure towards under- or overexposure. If your subject is dark, you might want to give slightly more exposure to reveal detail. If your subject is light, you might want to give slightly less exposure to retain detail. Just keep in mind that the proper exposure for a given scene depends not only on the film type you're using but the color of your subjects.

56 A Simple Test

© Steve Sint

Wouldn't it be nice if there was one test (say, about a half roll of 35mm slide film) that would give you solid information on your accuracy of your shutter and auto diaphragm. If I know that my f/stops and shutter speeds are about where they are supposed to be I'm well on my way to getting properly exposed photographs. Well, there is such a test, and it's easy and worth doing.

As luck (and the photography gods) would have it, f/stops and shutter speeds both work in multiples of two. What does this mean? Each f/stop lets twice as much light pass as the next smaller one. Each shutter speed lets in twice (or half) as much light as the shutter speed before (or after). Imagine the light is passing through a pipe onto your film. You can have a big pipe (big f/stop) open for a short time (fast shutter speed) or a little pipe (small f/stop) open for a long time (slow shutter speed) to let the same amount of light pass through. This means you can use one f/stop-shutter speed combo to test another f/stop-shutter speed combo if you pick equivalent pairs.

Load a slow speed slide film, get some 3 x 5" index cards, and find a place with consistent light. Direct sunshine (frontal, between 10 am and 2 pm) comes to mind but any CONSISTENT light will do. Take a light reading and pick a large f/stop and fast shutter speed combination. Write it on a card, and then write the other combinations (on other cards) that equal your first exposure combination. For example, if your first choice is 1/1000 @ f/2.8 your set of cards will include 1/1000 @ f/2.8, 1/500 @ f/4, 1/250 @ f/5.6, 1/125 @ f/8, 1/60 @ f/11, 1/30 @ f/16, and (maybe) 1/15 @ f/22. You now make a series of exposures at the settings on each of the cards and include each card in the scene denoting its exposure. I usually use a shingled wall on my home as a test site but you can use any still life subject you want. Process the chromes.

Since each combination of f/stop and shutter speed equals the same exposure, ALL of your chromes should be the same density. If you place the transparencies side by side on a light table they

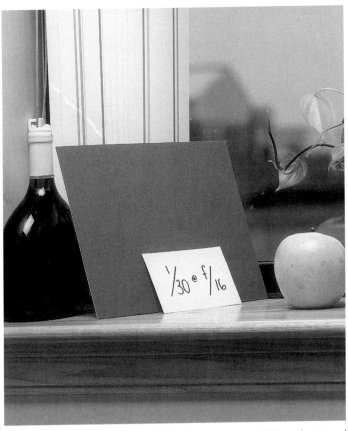

should all exhibit the same amount of exposure. If they don't and one or two are off there is a problem. Sometimes your fast shutter speeds will all be off (1/2000, 1/1000, 1/500, etc. Sometimes the problem might occur with your slow shutter speeds and some-

times the exposures are so erratic it means the diaphragm is sticking. If the chromes don't match one to another it's time to see a repairman.

Hints For Posing People

© Steve Sint

57 Don't Talk to the Back of the Camera

Here is the scenario: A photographer sets up her camera on a tripod, poses a customer and starts to direct her subject. The photographer is framing and focusing and her mouth is pressed to the back of the camera. The directions to the subject (probably the most important part of the photograph) are coming from a squished mouth which is talking into the back of the camera! Nobody hears anything except some mumbling. When you direct a subject make eye contact, not camera-lens contact. Speak to the subject so that he or she can hear you and understand what you are saying.

If you really want to get classy when directing people, learn to think backwards. If you want your subject to move his hand on the right side of your picture, he must move his *left* hand. If you can do this "change over" for the subject, it makes things run smoother.

© Steve Sint

58 Getting Close

Many photographers have a wide-angle lens to get more into the picture. They don't want to be standing with their back to the wall and still be cutting off Uncle Willie on the edge of the family portrait. While getting more in is certainly a valid use of a wide-angle lens, it doesn't begin to tap its many true resources.

A wide-angle lens can be used to emphasize a particular part of a scene. This is easier to explain by example so follow along with me. You are standing in front of a waterfall with some beautiful day lilies at your feet. If you put on your wide lens you'll get the lilies and the waterfall in all their glory. While the picture will

be nice, it may not be the breath-taking image you want. On the other hand, you could get down low and get in *close*, so the lilies tower over the camera. Your wide-angle scene will still be there but now the lilies will frame the waterfall and become a much more dominant part of the scene. For lack of a better term, the lilies will "frame" the waterfall and the picture won't be one you see everyday. When you push in with a wide-angle lens, you will accentuate the object close to the lens and the rest of the scene will fade into the background.

It's a pity that camera brochures never show you this when they demonstrate their lens lineup. Those brochures always demonstrate how the perspective changes with different lenses while keeping the subject the same size. The real strength of the wide-angle lens is the emphasis it places on a foreground subject. Put this ability to use. Next time you photograph a baby creeping around on the floor get down low, really low. Try to see things from the baby's perspective. You might get the beaming parents in the background and by coming in low and close on the baby, he or she will be the main subject. Remember, if your wide-angle lens focuses down to 12 inches, you can get in there and the picture will be a "show-stopper."

59

© Steve Sint

Make a Change

One of the most frustrating things about doing group pictures is sorting through the negatives. You arrange the whole family for a picture... three generations of adults... umpteen grand children... grandparents sitting erect in the middle. Next you shoot 10 frames of the whole kit and caboodle. After you show everyone the 3 X 5s there are lots of oohs and ahs AND everyone wants a reprint. Except.... Mom wants the shot where the grandchildren look best, Sister wants the shot in which she didn't blink, and Dear Auntie wants the picture where she was looking at the camera instead of the wriggling little kids. Each person wants a

different frame and it's almost impossible to tell which negative goes with which picture.

You can save yourself untold hours of head scratching if you change something in every frame. Cousin Billy on the edge of the group can have his hand by his side in frame one and you can have him put his hand in his pocket in frame two. Uncle Charlie can move his hand to his daughter's shoulder in frame three and in frame 4 two grandchildren can change places. The change should be radical enough to easily see the difference on a negative.... a frown changed to a smile just won't cut it... but it shouldn't make a difference in the content of the photograph. It's easy, it's quick, you can even joke with your subject by telling them why you're doing it, just do it... you'll be glad later.

60 Broad vs. Short Lighting

© Steve Sint

About 20 years ago I was a photographer for a fine New York portrait studio. As a test, the studio owner told me to pose and light a client of the studio. Dutifully, I did what I was told. After I was done, the owner told me that my posing was great but that I had lit the face from the wrong side. Being a kid with a well-developed ego, I told him he didn't know what he was talking about. He then explained what I had done versus what I might have done. He was right. To this day I remember his lesson and apply it all the time.

Most often, when we photograph a person, the face isn't exactly square to the camera. Usually, we only see one ear (isn't it queer... only one ear... sorry). Whenever you have a face presented to the camera with only one ear showing the face has two distinct halves. One side, with the ear showing is much wider (broader) than the side without the ear showing (which is narrower... or shorter). If you place your main light on the side of the subject that has the ear showing you are lighting the broad side of the face. This lighting technique does three things: it makes the face look wider (remember it's the *broad* side), it lights up the ear, and it lights up

Broad lighting

the jowl below said ear. For a majority of the world's people this is not flattering. If, on the other hand, you light from the side of the face that doesn't show the ear you make the subject look slimmer (remember it's the *short* side) and throw the ear and jowl into shadow. If you place your main light carefully, the shadow from the subject's nose will form a triangle of light on the broad side of the face that defines the face without showing off features that you want to hide. This simple technique will shave pounds off your subjects and make you a hero. Study the photographs so it will be easier to understand.

Short lighting

61 Low Key and High Key Portraits

© Steve Sint

There are three types of portraits. First there is the garden variety photograph in which the subject's clothing and background were chosen with care but without consideration of their tonal value. These photos may be beautiful but if a photographer is setting up a portrait from scratch, he (or she) can make the image a "stopper" by coordinating clothing and background. Two types of portraits immediately come to mind:

Low key

One is called a low key portrait in which the subject's clothing and the background are both darker tones. When you do this the result is often electrifying because the face is the brightest part of the photograph and the viewer's eye is drawn towards it. One sticky wicket in a low key portrait happens when the subject's hair is dark. The hair and the background merge together and the top of the subject's head disappears into the murkiness. I get around this by using a hairlight that causes the hair to halo and separates it from the background.

The opposite of the low key portrait is called a high key portrait. While you choose dark clothes and background in a low key

High key

photograph, high key demands light clothes and a lighter background. The subject doesn't "pop" off the page (as it does in a low key picture), instead the entire picture has a light and airy feel. I often like the dream-like quality of these pictures. Additionally, the light colors create a flare-ridden situation which does wonders for peoples' complexions. To shoot your own high key effects, you have to put a light on the background. The background exposure should be 1-1/2 to 2 f/stops over the exposure on the face. Any less light and the background won't be light enough; any more will wash it out completely. It requires the photographer to walk a fine line but the results are worthwhile.

Filter
Tricks

62

© Steve Sint

The Most Useful Filters

There are so many filters to choose from. There are just about as many filter manufacturers. If you carry one filter of each kind, you'll find that not only do you need a case just for filters but you also may need a wheelbarrow for your filter overflow! On the other hand, the reality is that just a few filters do most of the things we need filters to do. Let's go through a most-used filter list with the goal being simplification. The first separation in your filter thoughts should be whether a filter is for color or black and white work. Let's discuss color first.

Blue to clear graduated filter

Aside from soft focus filtration, truly mandatory color filters are pretty easy to decide upon. Number one on many photographers' (including me) color filter list is a polarizer. Forget about taking reflections out of glass; very often the reflections are what make

the photograph exciting. The real advantage of polarizers is saturated colors: blue, blue skies.... white, white clouds. No one filter can give you a postcard sky better than a polarizer. Except, maybe a graduated neutral density filter. Graduated neutral density filters cut exposure to part of the frame and gradually blend to full exposure by their midpoint. When you want a deep sky (or setting sun) plus foreground detail, the graduated ND (neutral density) filter is the one to have. Many manufacturers, such as Tiffen® and Cokin®, even add color to the shaded part of the filter, giving you a choice of many differently hued gradients. While a standard graduated filter fades from gray to clear, colored ones fade from blue to clear, red to clear, or sepia to clear. Red to clear can certainly jazz up a sunset, but if I could get only one, I'd choose a gray to clear every time. If I could squeeze in a second it would be a blue to clear graduated filter. Why? The one thing that kills most great scenic photographs is a white sky. In fact, my agent says, "If the sky isn't blue... DON'T shoot it!" While this rule gets trampled by sunsets, storm clouds, lighting storms, and a host of nature's flights of fancy, it's still a pretty good rule. My blue to clear graduated filter lets me carry a blue sky in my bag. Talk about a pocketful of miracles.

For either color or black and white work, a star filter is a good universal choice. It is just the thing to jazz up tiny point sources of light in your scenes. Candelabras become "Kodak moments," "Anytown, USA" looks like Paris... just by mounting this filter on your lens. These filters are made with 4, 6, or more star points, and you can easily orient the filter any way you want.

If your scene doesn't have the tiny point sources of light that allow the filter to do its thing, don't overlook the idea that a star filter can also be used for a soft focus effect (the more points, the more diffusion you get). Sometimes this one filter alone is enough to get you through a shoot!

For a nostalgic effect, use this trick: A sepia filter makes color photographs look like old-time, toned black-and-white images. If the customer wants the look old-fashioned look, it doesn't matter whether your photos are done traditionally using the smelly darkroom process or by filtering color film and sending it to the lab. I prefer the filter because: 1.) I hate working in the darkroom (I'd rather be shooting...) and 2.) I don't have to load black-and-white film for just one shot. This is really a weird filter

that doesn't fit either the color or black-and-white category. So, consider it "a filter of a different color..."

Next on my list a slight modification on another standard rule. Many recommend a skylight filter but instead I carry an 81A filter for my people photographs. This slight warming filter does great things for skin tones in open shade. Considering that I always try to do portraits in open shade (indirect light), the 81A is my ticket. If by trial and error your 81A still produces "cool" skin tones then you might try an 81B (slightly stronger than an 81A). The 81 series of filters goes up to EF (81, 81A, 81B, 81C, 81D, and 81EF) and you can pick your favorite brand of tonic depending on film choice and coolness of the light... for me that's an 81A. Last on my list is a color correction filter for fluorescent lights and daylight film. While film manufacturers can give you specific info for specific films and different fluorescents, I just carry one Singh Ray® correction filter. Most times it's very close. Not counting a few soft focus additions, these four filters are enough for me... most of the time.

If black and white is your thing, your filter requirements are less. A yellow and an orange will darken skies but keep clouds white. If you want to go for a seriously darkened sky, a red filter will give you that drama at the same time it will cut through ultra violet haze that sometimes makes skylines into a gray mush. As in color, I still include my graduated ND filter (only the gray to clear one) and sometimes (because it's always with me) my polarizer. While I constantly use soft focus filters in color work, I don't use them very often in black and white because they lower subject contrast, something I like. If you shoot a lot of black and white portraits you might try a green filter because it smoothes out skin tones.

Filters (especially circular polarizers) are expensive, so to save the budget, you might consider buying your filters to fit your largest lens and then buying step down rings to mount them on smaller lenses. This is especially true with polarizers. If you do this you might give up the use of a lens shade but the filter savings are real.

© Steve Sint

63 Bridal Veil Soft Focus

Today's lenses are sharp... ask many photographers and they'll tell you, too sharp. Very often you don't want to expose every mole, pore, hair, and wrinkle on your subjects' faces. For me the answer is soft focus filtration, and I have a few ways to get it. My favorite for the results, ease of use, and cost is bridal veil material. I don't use white though; I prefer black veil material. While the white veil

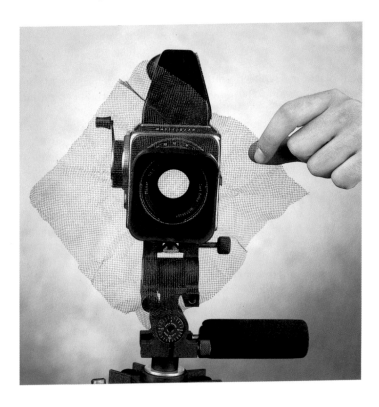

material works, I find that it makes the highlights glow in sort of a halo effect, and the image is much more prone towards flare in backlit situations.

I buy a yard of the material which is 45 inches wide for $1.69 and cut off pieces as I need them. My pieces are about 5 inches square so for $1.69, I get about 60 filters. In use, I stretch one over my lens and bayonet my lens hood on over the veil. For a softer effect, you can stretch it over the front of the lens hood. You can also take a lit cigarette and burn a small hole in the center of a filter before you stretch it over the lens. On the side of my prism I stuck a small square of hook Velcro® and when not in use my veil rides there. This filter system is cheap, effective, and easily replaceable in case you lose one. After all, there aren't too many other filters you can fold up and put in your pocket!

With bridal veil soft focus filter

Without filter

© Steve Sint

Nail Polish
Soft Focus Filters

Many photographers know about the creative and beautiful effects available by smearing some Vaseline over a filter or piece of glass that is then placed in front of the lens. Colors merge and blend in a painterly way but when you're done shooting you're left with a messy cleanup job. While cleanup in the studio isn't very difficult, it can be a problem in the field and, more importantly, the

With filter

effects you achieve are not easily repeatable. There is a way to get these smear effects with a material that is semi-permanent and, once in use, not at all messy. You can find it at the local cosmetic counter. Would you believe clear nail polish?

I have a variety of skylight filters that I have committed to an existence of having clear nail polish sloshed on their surface. Here's how I made mine: On different filters I have painted wavy, radiating, lines of polish and left it to dry. On others I have swirled patterns of nail polish and on others still I have stippled the nail polish when it was semi-dry to create translucent areas. On my filters I usually leave a dime sized hole (approximately) untouched by the polish and this "clear" area is always placed slightly off center. With most "store bought" center sharp filters the clear spot

is always dead center, and if you frame a portrait in the traditional manner the subject's chest is sharp while the transition to soft focus always runs over the face. You would think that with everything written about putting your prime subject off center in a composition, the manufacturers of center clear filters would get the message... but NOOOO... we have to make our own. The nice thing about the nail polish trick is that if you are unhappy with a filter you've made it can be rescued with a little nail polish remover and you can try again.

My favorite camera uses bayonet filters. I go so far as to file a mark on the filter's ring so that I can always orient my filter the same way. If I want to place my "clear" area in another part of the scene I hold it in front of my lens oriented the way I want. There are a few other points worth mentioning. It's best to see the filter's effect by stopping down your lens to the taking aperture and the effect of a given filter changes with different f/stops and different focal lengths. This is a powerful tool, but it will require some experimentation to get the effect you want. Since you're going to be mucking up the filters anyway, one saving grace of this tip is that you can (no, should) use the cheapest filters you can find. Remember to check out your photo store's junk bin for likely candidates.

EXTRA TIP: With today's wild and wacky nail polish colors you might not want to limit yourself to just clear nail polish. Any translucent color might be the thing you need to jazz up a scene. Along the same lines (the wild and wacky color craze) portraits aren't the only avenue open to you. Orange polish over a sunset might be great... maybe a green over a field or blue over the sky or water might be worth exploring. Ready... set... polish!

65 Vaseline Soft Focus Filters

© Steve Sint

As I've said before, today's lenses are sometimes too sharp. I've used cellophane, bridal veil, and nail polish to create soft focus effects, but there is still another technique that is very popular and

easy to use. You can get unique effects from Vaseline™ smeared across a skylight filter. Because these one of a kind effects often can't be repeated, they seem even more creative. More to the point, this soft focus effect is easy to create and that means it's worth including in your bag of tricks. If you like the effect you might consider dedicating a skylight filter just for use in your Vaseline photographs. Plus, don't forget to include a small tube of Vaseline and some cotton swabs in your camera bag.

You might be frustrated if you assume that just slapping a dollop of Vaseline on a filter will give you a terrific result. As with a lot of things, a little goes a long way and where you place that "little" has a lot to do with the final image. Try leaving some of your filter unvaselined (for lack of a better term). Or maybe using the Vaseline around the edge of the filter will work for you. If you decide to swirl the edges of the filter, remember that it will give you a different effect with different focal lengths and apertures. It pays to get used to previewing all soft focus effects at the taking aperture of the lens you're using. If you aren't happy with an edge swirl of Vaseline, you might want to try streaking it on, possibly in radiating lines from a clear area. While the area you're working with (the area of the filter) might seem small, the possibilities are endless.

Here's another idea to get your gray matter working: I mixed the Vaseline with food coloring and added colored swirls to some of my photographs. You know, green trees, green grass and swirls of green Vaseline! Try it on a blue sky... you might love the result. If you go the Vaseline route there are few other tips worth remembering: if you find a certain effect you love you can screw a second skylight filter over the first, Vaseline filter to preserve your Vaseline work of art. Or, to make the effect permanent, you could copy it on another filter with clear nail polish. Finally, remember that Vaseline can get messy, so carry some tissues (for removing the stuff) and a small trash bag (for getting rid of the messy tissues).

66

© Steve Sint

Rose-Colored Glasses

We've all heard the phrase, "looking at the world through rose-colored glasses". Actually, after trying on a pair, I can understand it. It's nice to look at things in their best light and sometimes it pays to put rose-colored glasses over your camera lens, literally. What I'm talking about are color temperature correction filters (sometimes called CC or Color Compensating filters) that warm up your images.

The first pro I ever assisted taught me about color cast. You know, when your pictures are slightly green, blue, or magenta. He said, "when you photograph people, any color cast is acceptable as long as it's on the warm side." It turns out that he was right. Make your photos warm(ish) and people have visions of flickering candles, fireplaces, and all that good stuff. It's the kind of thing memories are made of. You, too, can create a Kodak® moment anytime you want to.

I constantly use CC filters in the magenta and red ranges for portraits. These filters came in a graduated range of densities that starts with a low number and increases. For example, a CC 10 M (Color Compensating 10 Magenta) filter gives a slight magenta cast to a photograph while a CC 50 M (Color Compensating 50 Magenta) makes the resulting photograph look "Day-Glo." CC 05 Magenta and CC 05 Red filters do wonders for skin tones. The only time you have to be careful with this trick is when your subject is against a green background. Magenta filters turn green grass (for example) a murky, brownish mess. But in all other ways, everything is rosy.

67

© Steve Sint

Filters from Your Kitchen

Filters aren't limited to glass or gelatin planoparallel things that are placed in front of your lens. In fact, some of the most beautiful filter effects are created with objects that you wouldn't normally consider to be a filter.

There was a day when I forgot to bring a soft focus filter with me to an assignment. At the time I was at a loss, but only for a moment. Finally, trying to exploit my surroundings (and my creativity) I tore the cellophane wrapper off my cigarette pack (they were still socially acceptable then) crumpled it up, straightened it out, and shoved it into my lens hood. Guess what? My makeshift filter worked very well, so well in fact, that it became a regular in my filter arsenal. Later on, taking the idea a step further, I used a lit cigarette to burn a hole in the cellophane. My very own center-clear filter was born. Today I use bridal veil, Vaseline™, plastic wrap, and nail polish for soft focus effects, but in a pinch, the old cigarette wrapper will do wonders.

Cigarette wrappers aren't the only everyday items that can be used as a filter. Almost anything translucent will work. One photographer I know showed me some beautiful photos done with a plastic cup over his lens! He spent some judicious moments with a translucent plastic cup and pinking shears to create something different. He went one step wilder when he colored the cup with translucent magic markers. The swirls of color combined with the softening from the filter to surround his subject with a riotous rainbow.

A while ago I had to simulate beams of light passing between the eyes of two mime masks (the concept was "seeing eye to eye") and I used Plexiglas™ rods through which I passed yellow filtered strobe light. Guess what? The rods didn't show any color at all. I sanded the rods with fine sandpaper and, sure enough, the sanded surface transmitted the light, making the rods read as yellow... but they still didn't glow. To achieve the glow I wanted, I rigged a sheet of clear Plexiglas a few inches in front of my lens

and roughed up its surface with the same fine sandpaper. I was careful to only sand a band across the Plexi that corresponded to where the yellow rods were. The rods in my final composition glowed like a house-a-fire... I never told the art director I did it with sandpaper.

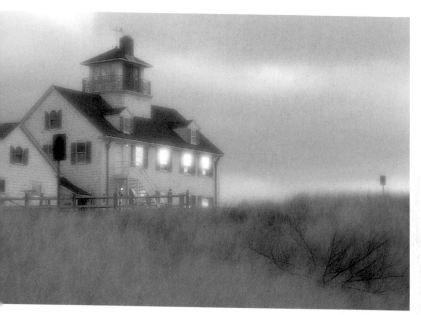

Photo: Joe Meehan

While you might want to copy my ideas, a better way to go is to use them as a springboard for your personal creativity. Stick *ANYTHING* translucent in front of your lens and look through the camera, check your effect using the aperture preview on your camera, and then push the shutter release button. Your new "filter" may be just the one you're looking for.

Flash Tricks, Tips and Hints

68 Dating Disposable Batteries

It's hard to keep track of when to change disposable batteries. In the old days you had two button cells in a Gossen meter and that was it. Today cameras are a battery dependent environment surrounded by a battery dependent supporting cast. For 35mm, I use three bodies, two meters, two flashes, and two radio slaves (two transmitters and two receivers)... they all use batteries. While I still use a roll film system that is mechanical, the meters, strobes and radios are all still in use with the larger film camera. The problem is determining when batteries must be changed and keeping track of all the equipment.

In my system, each meter and radio slave has a small piece of gaffer tape placed over the battery compartment door. On this tape, I write the date that I last changed the batteries with a permanent marker so my sweaty hands don't smear the information. Checking the dates on each piece lets me know which are due for battery replacement next.

Nine volt batteries are standard fodder for my radio slaves. Touching a 9v's contacts to my tongue (for a split second) lets me know if the battery is still good. A "hot" battery gives my tongue a little jolt followed by an acrid taste in my mouth. A flat battery doesn't do either of those things. While this may seem gross to some, it is effective and quick, and more importantly, I always have my tongue with me. If you have a heart condition or wear a pacemaker, check this tip out with your doctor before trying it!

For the button batteries used in my meters, I have a different system. While most buttons last for about 1 year (depending on use), I feel more comfortable changing them every six months. Remembering when to change them is easy. Every New Year's Day I change meter batteries. Six months later, on my birthday (mid June) I change them again. If you birthday isn't in June you can pick Father's Day (or Mother's Day, for that matter) for the second yearly battery change. While this seems simple (it is), I still tape the meter's back with my date note because as I get

older I don't want to face my birthday and sometimes I even forget.

I don't know if you are aware of this but there is a AA battery revolution going on as we speak! Eveready® has introduced lithium AAs marketed under the brand name Energizer™. While the new lithium batteries last 2 to 3 times as long as comparable alkalines, their real claim to fame (in this writer's eyes) is their lower weight. According to Eveready, the average alkaline AA weighs approximately 0.8 ounce while a lithium AA tips the scales at about 0.5 ounce. "Who cares about 0.3 ounce," you might ask? Well... you should. Here's why: The standard equipment in my 35mm bag requires 24 AA batteries to keep all the bodies and strobes powered. If I save 0.3 ounce 24 times I'm carrying 7.2 ounces less. That's enough savings to include another lens for the same weight. The weight savings doesn't end here however, "BL" (before lithium), I carried two complete sets of spare AAs. Now with the lithium AA's extended life span, I carry only one extra set, and it's rare that I have to use them on a shoot. The total weight savings is tremendous! 72 alkalines (3 x 24) at 0.8 ounce weighs a total 3.6 pounds, while 48 lithiums at 0.5 ounce each weigh only 1.5 pounds. The next time you have nothing to do, try to spend the day carrying around 2.1 pounds and see how it affects your outlook. Enough said!

69 Checking the "Sink"

© Steve Sint

One big advantage of using a leaf shutter camera is your ability to check the flash sync (synchronization) easily. There is nothing that puts a flash photographer's mind at ease faster than knowing that the flash and camera are on the same page of the play book. In truth, it's one of the first things taught to a green assistant. Before you teach them however, you have a little fun. You tell the neophyte to check the sync and when he (or she) asks how, you tell them to go into the kitchen and make sure the faucets work.

Ha, ha, very funny. The advantage of this rite of passage is that very few assistants ever forget how (and how often) to check sync. Just for the record I thought I'd explain the procedure here... and you don't even have to go into the kitchen.

On a LEAF SHUTTER (only) camera, attach the flash unit and the sync cord. With the camera empty and the camera back open, you aim the camera at a light-colored wall and, as you release the shutter, you look through the camera from the back (where the film goes). If you see a circle of light when the shutter and flash fire you are indeed in sync. As long as you're back there you might fire off a few more blank exposures at different apertures to check that the auto diaphragm system works. If you are using a smaller f/stop (higher number) you will see a smaller circle, and larger

f/stops (lower number) should let you see a larger hole. Consider changing the shutter speeds a bit also so you can be sure your leaf shutter syncs at all of them.

On all of my assignments I check my sync at breaks in the action and before I start just to be sure. This way if I lose sync at anytime maybe I can go back and redo the photographs I did since the last time I checked my sync.

70 Keep a Second PC Cord Handy

© Steve Sint

One of the most frustrating parts of flash photography is the lowly PC cord. This *very* thin wire cord is always being stretched or twisted, pushed or pulled until it just plain gives up. When that happens you have an expensive flash and an expensive camera with no way of synchronizing them to each other. Many photographers realize how important the sync cord is and they always keep a spare (spare<u>S</u>!!!) ready. When a PC cord breaks or becomes erratic, however, most pros can't seem to just throw them out. Instead they tie a knot in the cord (to denote its demise) and they put it back in their ditty bag (you know... the one for PC cords). Maybe throwing the cord out is too much like throwing away $20 or maybe the photographer expects divine intervention to magically heal the cord. In any event the outcome is the same. Sooner or later the photographer is frantic for a new cord and when he (or she) checks the ditty bag they're faced with 5 or 6 knotted cords and no new, good ones. With this in mind, the first sync cord tip is two fold: Always carry a few spares and always throw out the cords that are no good. Just knotting them doesn't help!

How would you like to have a second PC cord always at the ready? No fumbling through camera cases... at the ready... right now. You can do this with some small cable ties (the removable ones) from an electronic store and some nail polish. Take two identical PC cords and mark both ends of one of them with some red nail polish. Lay one cord right next to the other and use two cable

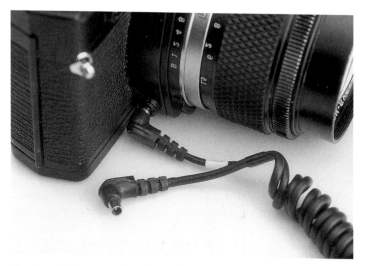

ties to attach one to the other. What you've ended up with are two parallel cables, one marked with nail polish and the other plain. When you thread this double cable through your rig and attach one cable to the flash and camera, your second cable is all ready to go. If your sync cord fails, simply detach it and reattach the second cable in its place. Do that at both ends and you're back in business. Sometime later you can check out the offending cord but till then you're still shooting with virtually no interruption.

71 Make a Receiver Plate

© Steve Sint

I use radio slaves. Light actuated slaves are lighter, cheaper, less finicky, not battery dependent, and even more sensitive. Then why do I use radios (or even infrared)? Have you ever noticed how many amateur cameras have built in flashes? Did you know that most point and shoot cameras with built-in flashes have relatively slow lenses so the flash fires much of the time? Now, I think it's

great to have people take pictures but I don't think it's necessary for them to use my multiple lighting setups because they are firing my slaved flash units. In the first place, they (the point and shoot flash camera contingent) can eat up my precious supply of battery power very quickly. In the second place, their red-eye reduction, multi-flash cameras can give a light actuated slave fits. To make a long story short, I use radio slaves so that I can peacefully coexist with other flash toting photographers.

The problem is that my radio slave receivers are square little boxes, and my strobe heads (where the sync connection is) are round (or another irregular shape). That's why near the top of my light poles you'll see a small aluminum plate. My plates are attached to the pole with 1/4"-20 flat head bolts that are counter-sunk into the plate. The bolts then pass through the light pole and are secured with aircraft style self-locking nuts to make every-thing secure. On the plate (over the countersunk screws) I've attached a piece of the hooked side of Velcro® so my radio receivers (which have a patch of the looped side of the Velcro® on their backs) can have a safe place to sit.

Velcro® is really indispensable. In addition to the patch on the aluminum plate, I have a patch on the side of my strobe genera-tors so I can attach a radio slave receiver when that's where the sync connection is. If you remember at the beginning of this thought I mentioned that radio slaves were finicky. Well, on the side of each radio transmitter I use is another piece of Velcro®. Onto this patch I stick a Velcro® equipped light actuated slave. That way when my radio starts to flip out I have a replacement at hand. This idea came to me as I watched my first assistant set up my equipment for a shoot. He attached the radio slave receiver to my strobe pack and on the floor right next to the pack, he placed a 30 foot extension cord with a PC cord attached to the end. I looked at him and asked why he did that. He said, "When the radio messes up I'll have a hard wire connection ready to go." If you go through my cases you'll find all important equipment backed up with spares. On stuff that goes down (breaks) regularly (like PC cords), I carry spares three or four deep. My assistant, Jeff, was just being prepared... just like I try to be.

72

© Steve Sint

Modifying Slave Sensitivity

Because I constantly shoot subjects that require the light of multiple flash, I use slaves. The cheapest and simplest to use are light-actuated slaves. Today, these peanut (or walnut) sized wonders even work fine outdoors... most of the time. Light-actuated slaves sometimes become befuddled in high ambient light situations such as bright outdoors or under the glare of video lights. I've also discovered (by luck) that there is a simple solution to the "high ambient light/slave won't work syndrome."

Try this if your slave doesn't work under bright conditions: Cover the slave with a handkerchief or paper napkin and try it again. Usually if you lower the ambient light to a level that is below a certain threshold, the slave works perfectly. If the napkin/handkerchief trick works, try making it permanent by covering the slave's sensor with a piece of strapping tape (the semi-transparent tape with fiberglass threads running through it).

When I'm using a light-actuated slave under video lighting, I often make a mini snoot from a piece of gaffer tape rolled around the slave's sensor. Sometimes, I've made a mini-barndoor from a tiny flap of gaffer tape. Both of these little tape accessories have enabled a light-actuated slave to work reliably under bright conditions.

Along these same lines, I've often plugged the slave into a long extension cord and run this cord from the flash to be triggered so that the slave was closer to the master light. In this case, you're not changing the slave's sensitivity but changing its distance from the tripping light. Both ways work.

Modifying Your Flash Bracket

Many photographers treat photo equipment like a Van Gogh painting. They enjoy the beauty of the design and revel in the luxury of the feel. As far as I'm concerned, usually the photograph is what's important... the camera is only a tool. Carpenters don't think about their hammers, they're more interested in the cabinet they're crafting or the house they're building. They respect their tools and take good care of them but the tool isn't the end goal. Like them, I use cameras and camera equipment to make photographs (my goal) and anything that lets me do a job better or more easily is worth investigating. Don't get me wrong, I also occasionally admire the feel and look of a classic camera that should be held inviolate but those rare pieces are treasured items that aren't often used.

My flash bracket is another story altogether. Drilling a hole, cutting off an edge, all in the search of faster setup or easier use is totally valid to me. Many pros I know feel the same way. In fact, most large cities have, as part of the photo community, a repairman who can form or modify a flash bracket to meet a photographer's personal preferences. One favorite modification in my neck of the woods is adding four little feet to the bottom of a flash bracket so your camera doesn't topple over when you put it down. This idea was the brain child of a local repairman who listened to a photographer's gripe and solved the problem. Flash bracket modification, however, is not brain surgery and with a file, drill, some sheet metal (or aluminum bar stock), you too can customize your "rig." As a case in point, look at the photo of my flash bracket. My bracket has been cut, drilled and filed to work for me. The wooden handle has a groove cut into it where my left thumb rides (it doesn't really help... my left thumb still has a callous). More importantly, my battery-powered flash (a Lumedyne®) has a hex screw on the bottom of the head that used to hang up on the bracket when I tried to swivel the strobe head for a bounce effect. No problem! I took a file and cut a groove in my bracket so that the hex screw on the strobe head had a slot to slide into. Prob-

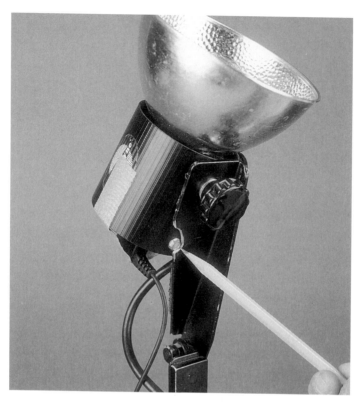

lem solved. Now there is always more than one way to cross the river and a few washers under my strobe head would have also done the trick. When I decided on the groove route I didn't have any washers handy but I did have a file...the solution was obvious. If you don't hold equipment as sacrosanct you can do just about anything you want... after all it is your bracket and it's really the picture that counts.

74

© Steve Sint

Aligning Your Quick Release

Moving a camera from a tripod to a flash bracket can be agonizingly slow. While your subject is waiting, you are fumbling with your tripod screw. You know the drill: the tripod screw starts into the camera hole... whoops it missed... the tripod screw starts into the camera hole... whoops it missed... ad nauseam. One way around this exercise in frustration is to use a quick release coupling. The trick is to use one on the tripod and one on the flash bracket. However, frustration rears its ugly head once again when the quick release on the flash bracket starts to turn on its tripod screw. Oh the agony! Probably one of the most often checked items when using a flash bracket is the alignment of the flash head and the lens axis. Photographers are always worrying this to death.

One way around this dilemma is to make a stop against which the quick release coupling on the bracket can rest. If the joint between the bracket and the stop is solid and the mating of the quick release coupling and the stop is tight, alignment worries are a thing of the past. On my strobe bracket I added a piece of brass 1 inch long by 1/4 inch wide by 1/8 inch thick. This piece was butted up against my quick release coupling and clamped in place with a small "C" clamp. I then drilled two holes through the brass bar and the strobe bracket and then threaded these holes for 4-40 machine screws. Once the "stop" bar and the bracket were screwed together, I reattached the quick release so that it rested against my newly installed "stop" bar. On my flash bracket, a misaligned quick release coupling is now a thing of the past.

Key Rings to Hang Packs

Heavy flash shooters realize early in their careers that penlight batteries aren't the way to power strobes. A slew of aftermarket and OEM battery packs exist with quicker recycle times and with more flashes per battery (or charge). Some high-end systems even start off with a separate battery pack as part of their design.

A shoulder strap or belt clip is fine for a flash that's mounted on your camera but when you want to mount a strobe/battery pack combo on a light stand, you find yourself in a bit of a pickle. If

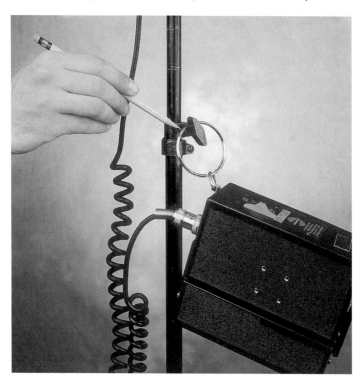

you place the battery pack on the floor next to the stand, a simple stand movement becomes a two handed job... one hand on the pole and the other on the battery pack. If you hang the battery pack from the stand by its shoulder strap you create three other problems. First, with the battery pack at the low end of the strap you need more cable between the head and the pack. Next, when you try to move the stand the pack becomes a free floating weight whose center of gravity is nowhere near the light stand. Lastly, the thick, stiff straps that are comfortable on your shoulder slip off a light stand's locking knobs easily. Crashing a battery pack to the floor is no fun, especially because it usually topples the light stand at the same time. What to do... what to do?

At my local hardware store (gee, I love that place!) I found some simple key rings that were large enough to fit over the knobs on my light stands. By attaching the key ring to the ring used for the pack's shoulder strap, the pack was ready for hanging. The key ring costs pennies, weighs even less, puts the pack's center of gravity close to the stand, and doesn't fall off the stand's locking knobs. What could be better?

76 Call It a Kick Plate or a Fill Flap

© Steve Sint

If you want to travel light (pun intended) and fast you really can't beat a camera with a flash attached. Trouble is that if you shoot a camera mounted flash directly at the subject you get illumination akin to a coal miner's helmet light. While this "look" is often useful for documentation, it is not flattering for shooting people. One way around this is by using bounce flash. For the uninitiated, bounce lighting directs the flash at some broad surface instead of at the subject. From that surface the light bounces (hence the name) back towards the subject. It provides even, soft illumination that is ALMOST flattering. I say almost because ceiling bounce (the most common variant of bounce lighting) creates shadows under the subject's chin and nose, and plays havoc with deep-set

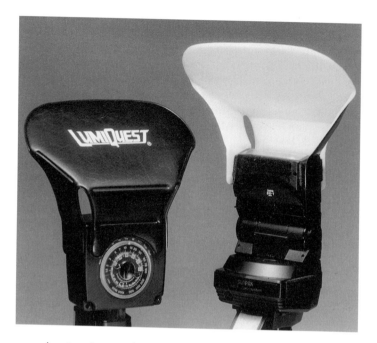

eyes, leaving them without a catchlight (to suggest moisture). One way around this ceiling bounce weakness is to get some of the light to do a second bounce off a small white card mounted on the rear of the flash head. This light ends up traveling forward into the deep-set eyes, and fills in the shadows under the chin and nose. Because it "kicks" light forward into the aforementioned evil shadows I call it a "kick plate." Because it fills in those same evil shadows others call it a fill flap. Either name... same device.

There are commercial kick plates available such as those made by Lumiquest® and some strobes even come with one built in, but they are so easy to make you might want to do it yourself. Around the head of my strobe (almost any brand) I keep a few rubber bands. I can stick literally any size kick plate I want under them. I've used business cards, pieces of white card stock, and even white plastic spoons. The spoon idea came to me from another photographer and while it doesn't do much for filling shadows, it does give the eyes a great catchlight. I've even used the palm of my hand as a kick plate but it gives my photos a bit of a warm cast (sometimes for the better). One thing worth

remembering is that the kick plate's color impresses itself on the light it throws forward... so use white if accurate color is important. If you're shooting black and white, any color kick plate will do. I often use a piece of yellow legal pad that I take notes on. All the paper or card kick plates I use fit under the rubber bands around the flash head. Just remember, the bigger the kick plate the bigger the amount of fill you are throwing forward into the shadows. You must decide how much fill you want.

77 Measuring Kick Plate Output

© Steve Sint

After reading the "tip" about fill flaps, or kick plates, I hope you've decided to use one when you do bounce flash photography (in normal-sized, white ceiling rooms, naturally). The question now becomes, "How big should I make the kick plate?" Well, the answer is... it depends! It depends on how much frontal fill you want. If your subject has deep set eyes (or many nooks and crannies) you might want a BIG kick plate. Smoother subjects will require a smaller amount of frontal fill. How big is too big and how small is too small?

If you have access to a flash meter (beg, borrow, steal, or buy one) you can figure out how much output you get from different sized plates. In fact, you might decide to use different sized kick plates for different sized subjects. Let's do some metering. First, to establish a baseline for comparison, mount your flash on a tripod or light stand and take some meter readings while bouncing the flash off the ceiling. Now for fun, put two light stands on either side of your flash unit and mount an empty cardboard box (upside down) over your ceiling directed bounce flash. Don't cover the flash with the box. Just make sure the bounced light is directed into the box. Everything will be OK if you don't get any reading with your flash meter when you fire the flash into the box. Start attaching different-sized kick plates to your flash unit's head and take a meter reading of each plate's output.

What you've done is divided the flash output into two components: the light going up (the bounced light) and the light being thrown forward after hitting (reflecting off) the kick plate. The overhead box traps the light going up so you are just working with the kick plate component. Personally, I like a kick plate output that is 1 to 1-1/2 f/stops LESS than my bounce light exposure. However, the great thing about photography is that your tastes and mine differ (that's what makes horse races). With your overturned box you can figure out how much fill light you're getting from each different-sized kick plate and you can decide for yourself.

78 Angle in on a Lapel

© Steve Sint

A few years ago I was watching a very good photographer focus her roll film SLR and every time she reached for the focusing ring she cocked her camera on a 45 degree angle. After watching her for a few moments I walked up and said, "You learned to shoot on a Speed Graphic." She said, "Sure did... How'd you know?" I told her about the old days when photographers shot with 4 x 5 Speed Graphics equipped with side mounted Kalart rangefinders. Those rangefinders were dim in bright light and difficult was an understatement when you considered their low-light capability.

Crafty photographers, always looking for a way to get the job done, used a man's coat lapel to focus on because it took advantage of all the rangefinder's strengths. A dark lapel against a white shirt presented the photographer with a straight line of black against white which made focusing in dim light at least possible. The trouble was that lapels are always on a slight angle and aligning the rangefinder with the lapel required a slight tilt of the camera.

Now it's 30 years later and when I use a rangefinder focusing aid at a formal-type shoot I still look for a lapel to focus on... and I still tilt my camera on a slight angle as I focus. It just works better.

79

© Steve Sint

Don't Look Through the Camera!

If you have a camera that has a pellicle mirror or is a twin-lens-reflex, skip this tip!

If you use normal(ish) focal length lenses, Single-Lens-Reflex (SLR) cameras are possibly the second-best way to view a scene being photographed. However, the SLR is limited because at the precious moment of exposure the mirror flips up to expose the film and the photographer can't see anything!

Some might argue that the photographer views the scene through the viewfinder immediately before and after the exposure so it doesn't matter. But after 25 years of shooting pictures of people I shout, "HOGWASH!!" People are the squirmiest, wiggliest, blinkingest things the universe has to offer. Therefore, under most "people-picture" circumstances the "best" way to shoot pictures is by viewing the moment of exposure with your naked eye... no camera in the way. Because of this, when I shoot people pictures, up close and personal, I feel like a turtle. It's like this: I view through the camera and frame my picture. I freeze my arms and body still. Without moving my body, I crane my neck and my face around the back of the camera and view the real scene as I push the button. The first advantage is obvious. You can see if your flash fired! But with a little practice you can see blinks, smiles that died (or crested perfectly), and a zillion other little details. All this is especially true if you use flash.

If you use wide-angle lenses (in 35 format—20, 24, 28, or 35mm or in 2-1/4—40, 50, or 60mm) regularly, the body freezing trick is even less critical if you frame your photograph with a little "air." When you use normal and longer lenses your framing accuracy becomes more important so you have to be very careful about holding everything still while you do your craning. Still, if you do "people," like "wides," and use flash, this is the way to go!

80 Stick with Velcro®

Sometimes a photographer can look at another photographer's equipment and pick up a few ideas. How each of us solves problems is different and incorporating other ideas into your own work style can lead to a new conglomerate style that becomes yours. When another photographer looks at my equipment one of the first things he (or she) will notice are the patches of Velcro® on my prisms. Not only will they see the Velcro® patch on my 35mm and medium format equipment but they'll find it on the standard of my

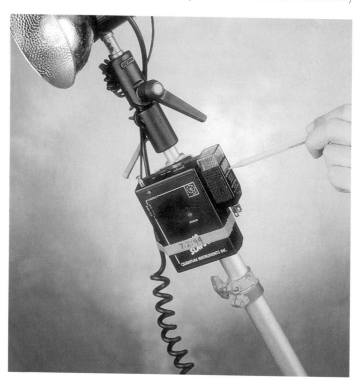

studio monorail or on the bed of my field camera. What do I use the patches for? Will some archaeologist in some future time think I was a follower of the Velcro® god? While I love Velcro®, I put the hooked side of the stuff on my cameras for another reason.

I use slaves and the transmitter box, which plugs into my camera's PC outlet, has a patch of the loop side of the Velcro® on its back. That way I can always "stick" my transmitter to the camera. If you use radio or infrared slaves and need a place to keep your transmitter while in use, nothing beats the camera to which it's attached. Additionally, my radio slave (infrared slaves work just as well) can be used to fire a motorized 35mm camera while I'm at another location (as long as I'm in range). Another Velcro® patch is on the back of my slave receiver so I can attach it to the camera if the camera is at the end of the radio chain instead of the beginning.

While being able to easily attach your radio or infrared transmitter or receiver to your camera is worthy in itself, I found another great thing about the hooked side of the Velcro® (that's the side that feels stiff and hard). It will grab onto my favorite soft focus filter (black bridal veil) and keep it handy. So if you see me shooting pictures and I don't have a transmitter on my camera (even I don't always use flash) you can rest assured a piece of soft focus veil will be stuck on my patch, just going along for the ride.

81

© Steve Sint

Electrical Accessories Worth Taking Along

Moving fast and light with battery-powered strobes is one way to take pictures when you want to augment natural light. On the other hand, a lot can be said in favor of AC strobes or hot lights. While battery powered units are convenient, they just don't have the bare knuckled power that a strobe attached to a wall outlet can generate. Additionally, while battery powered lights often are working at full power, AC lights offer so many choices of power selection that you can tailor your lighting to your needs, which

means better pictures. The fact that AC powered lights offer modeling lights (in the case of strobes) and they never have batteries that are too pooped to pop makes it easy to understand that if there is a wall outlet available AC lights outshine their battery powered counterparts. Finding that available wall outlet isn't always so easy. Two strobes on a circuit means popping breakers every time you shoot. Older buildings don't have grounded outlets and sometimes there are no outlets at all! Sometimes there is an outlet but it's 50 feet (might as well be miles!) away.

After many years of searching for an outlet (sometimes unsuccessfully) I've come up with a few adapters that weigh next to nothing, cost pennies (relatively) and don't take up much space; they have proved their worth in gold. Most hardware stores (even supermarkets) sell three prong to two prong connectors that are very useful in older buildings without standard grounded outlets. For safety's sake you should connect the adapter's pigtail wire to the outlet's retaining screw but even that is no guarantee of a grounded system. Very often in the rush of set up I've not bothered to do this but I cannot recommend it to you. If you don't get a solid ground and get hurt you're on your own. Sometimes there aren't two outlets available and I want to power two strobe generators. For these situations I carry little splitter boxes that convert a single plug to three outlets. Although I carry grounded and ungrounded versions, the grounded version is always my first choice. If you load one outlet with two generators it pays to know how much amperage your strobe generator draws. A helpful hint here is to remember that a 250-watt modeling lamp uses about 1-1/2 amps. In a pinch you can turn off (or dim) your modeling lamps to stop popping circuit breakers. Some strobe manufacturers have packs with two recycle rates (and different amperage requirements) and it pays to exploit every power-saving feature in some location situations. Additionally, some strobes are studio oriented, amp suckers so if location lighting is your thing you might investigate less amp hungry beasties.

Probably my favorite accessory in this group is a plastic piece that screws into a light bulb socket. It has a chain pull cord (for on/off) and a socket for another bulb on its end. More importantly, the side of the plastic piece has two outlets in its sides into which you can plug a standard plug. With this little wonder I can turn a wall sconce or any light bulb socket into a plug. A word of

caution however: these temporary outlets aren't grounded so proceed at your own risk! Sometimes the light bulb's socket is so deep that the outlets on the side of the casting aren't accessible because they're blocked by the deep seated bulb socket. In that instance I screw a second connector (same type) into the first which usually gives me the clearance I need. More that once I've gotten power from one of these little helpers and without power I can't shoot. Enough said.

82 Making and Using Barndoors

© Steve Sint

One of the easiest (and most easily packed) soft lighting tools you can use is an umbrella. From the standpoint of light quality versus weight, compactness, and speed of set up, umbrellas are hard to beat. With an umbrella's good points, however, come some pitfalls that are worth avoiding.

To get the softest effect possible, the light should be at the very end of the umbrella shaft. This way you are filling the total umbrella with light and you are making the light as large as possible. This, in return, softens the subject's wrinkles and skin texture. However, when you do this, some of your light spills off the edge of the umbrella and can easily flare into your lens.

Two pieces of equipment studio photographers use to eliminate this unwanted spill are barndoors and/or flags. Barndoors are things shaped like small, well, barndoors! They are two flaps that can totally cover a light when they are closed or totally expose it when they are both open. In addition, each flap (barndoor) can be opened independently of the other and wherever they are positioned they stay. Some manufacturers even make the two barndoors able to rotate around the rim of the light, allowing the barndoors to be placed at any angle. Flags, like barndoors block off some of the light coming out of a reflector but unlike barndoors they are usually not attached to the light's rim and they don't come in groups of two.

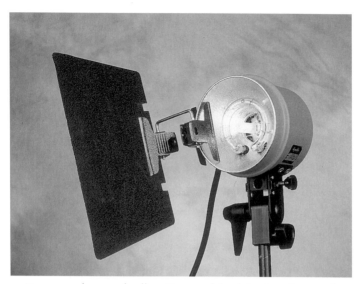

For me and my umbrellas, I've combined the two. I use a double-sided Bogen® Multi Clip that I attach to the edge of my light's reflector. Into the other side of the Multi Clip I put a 5 X 7 inch sheet of thin aluminum plate (mine are about 1/64 inch thick and painted black). By sliding the clip around the light's reflector edge and sliding the plate within the clip, I can position my barn-door/flag just about anywhere to stop light from bouncing into my lens. This, in turn, allows me to position my light and camera anywhere I want in relation to each other. If you go the Multi Clip route be careful because after a few moments of it being attached to a light it gets *VERY* hot!! I'm always using my handkerchief to adjust mine.

Some photographers I know have gone a similar route except they use different materials. One rig I've seen has Velcro® on the outside of the reflector. The photographer carries small pieces of card stock (about 5 x 7 inches) with the opposite side of the Velcro® glued on.

Any way you go it is a very worthwhile addition to your bag of tricks. One last minute thought: When I use my 4 x 5 view camera I often take the same Multi Clip and barndoor/flag and attach it to my front standard to shield the lens from spill. Same tool, same solution, different place.

Tips, Tricks and Hints for the Studio

© Steve Sint

83 Step Ladders

Here's a secret: In the trunk of my car beneath all my cases I have a 30-inch step ladder. The more photographs I take, the more times I use my step ladder. If I need to see over a crowd (or wall)....no problem. Need a place to sit a subject? No problem. Need to get an equipment case off the ground for easy access? No problem. Still, I didn't make a big deal about carrying a step ladder.

As a visually aware person I'm always looking at images and recently a picture stuck in my mind. During the O. J. Simpson car chase saga, CNN showed an image of the Simpson compound with the white Bronco behind the gates. While I wasn't that interested in the Bronco, I did notice something else. All along the compound wall, leaning against it, or set up, were stepladders! All the news teams had one in their trunk or van... just like me. After all the years I've carried my step ladder I feel vindicated. If you decide to lug around a 10 foot tripod, you better have a way of looking through the camera once it's up in the air. My stepladder and I get the job done.

© Steve Sint

84 Modifying a Step Ladder

As you know, I carry a step ladder with me. I use it to see over crowds, to get up to my camera when it's on a 9 foot tripod, and as a posing aid to create interesting group pictures of families and couples. In my travels I've seen many pros with step ladders and a lot of them have been modified by their owners to make them better suited to photo use. One video man I know has a quick release coupling bolted to the side of his ladder. In the coupling rides a

spare camera battery for his camcorder, always ready for a quick change. Another photographer has a foam rubber shin pad on his ladder's top step. He climbs up to the next to the top step and rests his shins against the foam. Still another shooter I know has a plywood box that clips onto his ladder's top step, giving him an extra 6 inches of height.

My ladder also has been modified, and that's what I'll be more specific about. I use a Wing Little Jumbo™ three-step ladder and, while the ladder is perfectly sized, I have modified it. My ladder has rubber feet that slip into the bottom of the legs. To keep the feet from becoming loose and getting lost, I drilled some holes in the legs and threaded in some self-tapping screws to hold the feet in place. This means my ladder will never scratch floors or rip clothes or carpeting. The screws cost less than a buck... good deal. Next, my ladder had a cross-plate brace that was pop riveted between the legs. When the rivets eventually loosened up and the ladder became rickety, I found a local welding shop that welds aluminum and had my cross brace welded in place... no more shaky ladder for me. While you may never get a Little Jumbo (although I'd be lost without mine), if you use a step ladder, you should study its weaknesses and try to remedy the situation. There is nothing like standing on a step ladder and having it break apart under you. Just try to look cool while that's happening!

85 Posing Drapes

© Steve Sint

One accessory that rides in every equipment case I use is a posing drape. I know, I know... a posing "what" you ask? A posing drape is a piece of material that can be used for a variety of things. I carry black ones that are about 45 inches square but gray, white, and other colors can also be used. Mine are simply a yard and a half of material (the bolt of material is 45 inches wide) with the cut ends folded under and sewn with a simple line of stitching. The stitching keeps the material from fraying and makes the drape

look neater and more professional. What do I use a posing drape for? Here are just a few suggestions: My black drape can be used as a quickie background for a head shot. I either tape it or safety-pin it to a wall or curtain but, in a pinch, I've even had an assistant or casual bystander hold it behind my subject. Often I use a hard camera case as a posing prop and if I throw my drape over it the case is hidden. For close-up photos of flowers I can circle the blossom with a drape to eliminate unwanted backgrounds. My black drapes also do double duty as a scrim (or flag) to block light from hitting some part of my subject or background that I want to stay in shadow. Finally, I've rolled one up and used it for a pillow when I needed a nap.

86 A Posing Drape Shutter

© Steve Sint

Now that you have a posing drape (see tip #85), you can use it to insure vibration-free time exposures. Whenever you are using a wristwatch to time a long shutter speed, you can bypass the shutter mechanism in your camera. Why would you want to? By opening and closing the shutter without touching the camera you eliminate vibration in the camera. Here's how:

I ball up my black posing drape and hold it in front of my lens so that it covers the lens without touching it. Next, either by hand or cable release, I trip the shutter on the "T" setting if you don't have "T," you can use a locking cable release on "B." If you don't have "B," consider buying a more advanced camera. After I wait a few seconds for my camera to "settle down," I uncover the lens by removing the balled up drape. At this instant, I start to time my exposure. At the end of the exposure I quickly replace the drape *before* I touch the camera to close the shutter.

If you have an electronically-controlled shutter with calibrated speeds up to 30 seconds, you can fit your long exposure into the camera's timed speed. When you do it this way once again, you eliminate any contact with the camera during the exposure.

No matter how steady we think we are, it's good to remember that our bodies are twitching masses of muscles through which fluid is constantly pumped while our lungs inflate and deflate all the time. My body is not the best thing to let touch a camera I want to keep perfectly still.

87

Clay and Sand for Hidden Support

© Steve Sint

I was once given an assignment to photograph some rings. To make my life miserable, my client wanted all the rings to stand up in the composition so the viewer would be presented with the gems in all their glory. This was a real head scratcher. In fact, I was glad there were no police on the set because if there were, my subjects (the rings) would be arrested for "no visible means of support." All kidding aside, this particular assignment really had me thinking. Here's what I came up with.

I built a rectangular framework of 1 x 2 lumber on a table top and filled it with sand. I leveled my mini sandbox with a steel ruler and then I spread a piece of satin over the sand's surface. The next step was easy. Very carefully I pushed the rings into the material and SURPRISE, SURPRISE, they stood up in the little indentations in the sand. What started out as a real problem became a "piece of cake."

Sometime later, another client wanted a single gem to be placed so that a specific facet was displayed. I needed firmer support than the sand. This time I pulled off the same trick with modeling clay. I rolled the clay into a 1/4 inch sheet with a rolling pin, but I ran into a problem. Unlike sand, the clay oozed oil (or something like oil) and this seeped into the material that covered it. One ruined piece of satin later, I decided that my system needed a little modification. I rerolled the clay but this time, I covered it with a piece of plastic wrap before I put down my material. The wrap blocked the oozing oil and I was home free.

The trick is not to get hung up on sand or clay (although both

ideas work well) but instead try to think of different things that can become a fixture to hold a prop.

88 Making an Armature

© Steve Sint

An editor and I were talking about a photograph I was just assigned to shoot for the cover of his electronics magazine. In the sketch, six microchips were floating over a reflecting pool with the sun rising behind the floating chips. This particular editor is a favorite of mine because in all of our many conversations he's always been able to reduce an idea to its essential components. After listening for a few minutes he said, "The real problem seems to be how to design a fixture to hold the chips." I thought about this for a moment and realized that he had struck the nail on the head!

Almost every still life studio photograph requires figuring out how to support the subject. A simple plain box sitting on a surface is (how should I put this?) *BORING*. Float the box one inch over the surface with a light, open shadow visible under it and the picture becomes (how should I put this?) *EXCITING*. Now a box is a box (of course, of course) and there is a limit to how creatively you can present it. By adding excitement to the scene surrounding the subject you can elevate the energy created by the image of the mundane (box).

Because a camera is a monocular system, a path directly away from the back of the subject (in line with the lens axis) will always be hidden from view and therein lies the secret! Now, the question begging an answer is what can you use along that hidden path to support the subject? In the example of the box, a smaller box can be taped under the first box towards its rear in such a way that it's hidden from view along the path I just described. Taping the two boxes to the surface can result in a cantilevered, floating box as a subject. But what about the micro chips?

Art supply stores sell stuff called armature wire in various thicknesses. This bendable aluminum wire will hold any shape it is

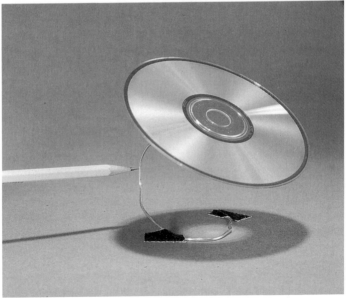

bent to. Artists use this material to form the skeleton onto which they put their clay sculpture. We've all seen statues of horses in mid stride with only one leg touching the ground. This is possible because of the armature enclosed in the clay. In my case, the micro chips were hot glued to a stiff piece of fine armature wire that was stuck into the background surface. The wire traveled back along the path hidden behind the subject. All I needed was a little retouching on the shadows caused by the wire armature.

Along the same lines, I once had to photograph some metal banded watches. A thin piece of armature wire bent into an oval kept each watch and watchband positioned as if there was a wrist inside it, only there was no wrist to be seen. MAGIC! Visit your art supply store, get some armature wire, and make magic of your own!

89 Monofilament

Have you ever had to make a pocketbook handle stand up or a floppy disc float over a computer slot? There's this stuff called Monofilament which you can pick up in a sewing store (or a Five & Dime) that can save the day. For 89 cents I got 150 yards of this transparent nylon thread that is about as thin as a fine human hair... except it's clear!

Whenever I have to float a lightweight object in a photograph I first think of monofilament. I use two light stands on either side of my set and rig a cross bar between them so that the crossbar is out of the camera's view. With bits of tape I attach monofilament to the bar. The monofilament trails down to the set and either loops under things (and goes back up to the crossbar) or ends where it's attached to the floating prop. With three strands of monofilament supporting a prop (sometimes I use a second crossbar on two more light stands) I can make the prop assume almost any position.

The real treat is viewing the finished picture. The monofilament disappears! Even if you can make it out under magnification, by

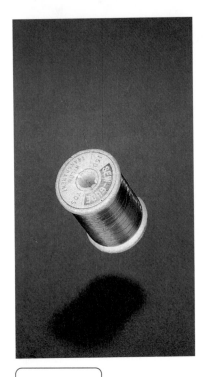

the time the photograph has gone through a screened printing process it's GONE! The only time the monofilament remains visible is if it's backlit and even then it's difficult to see. In the photo of my spool of the stuff, the spool is hanging from a piece of this clear thread.

90 Using Your View Camera as a Projector

© Steve Sint

Using a view camera is pretty standard fare for a catalog photographer but following a layout to the letter can be tiresome and sometimes downright impossible. A few years ago I photographed a tool catalog that drove me up a wall but in the process I came up with a great view camera trick that I'd like to share. The tool catalog layout called for one photograph that was truly a can of worms: 40 to 50 screwdrivers and pliers were to be laid out in circular rows according to a specific diagram. To make matters worse, the placement of each specific tool was important because the design firm commissioning the assignment planned to add an

The photo shows the camera, spotlight and acetate in position. Inset photo shows the projected image.

overlay of letters that keyed each tool to a description below the photo. While this may seem straight forward to a neophyte photographer, a seasoned pro knows this is no fun. I was given a diagram of what went where and I was left to my own devices. Devise... I did!

Let me start off by giving you a hint: Cameras and projectors (or enlargers) are basically the same except the light passes through them in opposite directions. To make my layout easier to follow I changed my view camera into a projector! My first step on this journey led me to a copy machine with a package of clear acetate (the kind that's safe for copiers) clutched in my hand. I made a reduction copy of the layout on the acetate so that it would fit onto my view camera's ground glass. Next, with acetate in hand, I went into the studio. On the studio floor I placed a sheet of plywood covered with seamless paper. I aimed my camera straight down at the "set". I focused the camera on the seamless (actually, I used a tool placed on the seamless) and then I taped my acetate mini layout to the camera's ground glass. Here's the great part. After darkening the studio and opening my camera lens I took a spotlight and aimed it through the back of the camera. *HOLY COW!* The image of my layout was projected onto the seamless! It then became simply a matter of putting each tool on its outline. This simple trick saved me hours of agonizingly slow, trial and error subject placement.

If this was the only trick I got from putting light through the camera the wrong way it would still be worth it but there's more. On another catalog assignment everything had to be photographed to the same scale. This means that when you put all the finished chromes in an enlarger all would require the same amount of enlargement to reach their final size. While the transparencies were never going to be placed in an enlarger by shooting them all to the same scale, the client could have the printer make "gang" color separations. This means all the photos were grouped together and were separated together saving "mucho" bucks. Here's how I did it: I took the largest, hand drawn layout and taped it to my studio wall. Next I taped a piece of acetate on my ground glass and aimed my camera at the layout. I moved the camera in close so that the layout's edges filled my frame. After focusing on the layout, I took a sharp grease pencil and outlined the layout's edges on the acetate which was on the ground glass. Now, *without*

moving the camera, I removed the first layout and replaced it with the second while also changing the ground glass acetate on my camera. I then proceeded to outline layout two on the ground glass acetate. When I was done with the whole pile of layouts, I had a bunch of numbered acetates that all required the same degree of enlargement to reach their final size. Pretty nifty! On this particular assignment I used the projection trick whenever I was shooting on a flat surface. Each time I did it I got a projection of the borders of my photograph. To say I was tickled puts it mildly.

91 Oval Holes and Background Poles

© Steve Sint

This is really a neat trick for budding studio photographers. When you start you often shoot alone since assistants are an expensive luxury. Alone is OK, but putting up a background by yourself can be awful. Raise one light stand... run to the other side.... raise the other light stand... etc., etc. Worse yet, the whole thing totters around as you do the "Wild Pole Chase" when you use a hollow top pole that has a hole drilled through it to accept the tips of the

light stands. If you take a rat tail file (called that because it looks like the tail of a rat) and file the horizontal pole's circular holes into ovals, you can raise one side of the background without a resulting bind on the other side. While this may not seem like much, it makes single person seamless use easy. All of this is much harder to explain in words than in photographs, so look at the photo, or better yet, try it!

Working With Painted Backdrops

92-101

© Steve Sint

This is a series of ten tips to assist you in using painted backdrops.

92

© Steve Sint

Sometimes it's nice to isolate a subject. While I often shoot "environmental" portraits, there are times when I want to eliminate the extraneous and explore the individual (either person or thing). The most common way is by using a roll of seamless paper but, aside from white, black or gray, I find it boring. In fact, white, black, and gray seamless are also boring, but sometimes I need a boring background! I do, however, really like using a sheet of dyed muslin. The cloth lends an organic feel to the picture and I have an option in how I hang or drape it.

A 10 (or 12) foot by 18 (or 20) foot muslin is great but it can be expensive (between $200 and $500). Muslins are cheaper than similarly-sized painted canvas backgrounds and, more importantly, they can be stuffed in a satchel for traveling to a location. Notice I said stuffed. If you neatly fold a muslin background, the creases will create a horrid checkerboard pattern that isn't very attractive. Stuffing your background into a sack will make it crinkle and wrinkle in all sorts of ways and this embarrassment of wrinkles will become a beautiful out-of-focus pattern.

© Steve Sint

93

Therefore, my next tip is to treat a dyed muslin backdrop like a dirty shirt you're putting in a laundry bag. Unlike your dear old Aunt Matilda this is definitely a case of the more wrinkles the better.

© Steve Sint

94

Since every muslin is unique, you will undoubtedly find that you prefer one side to another. This "Tip" is to mark your favorite top corner of the muslin (a felt-tipped marker will do). Then, when you stuff it into its sack, put the opposite, non-favorite corner in first so that the preferred corner is at the top of the sack. That way when you unpack your muslin you won't have to rummage through 200 square feet of cloth to figure out how to orient it. It'll save hours of time over the life of the muslin.

95

Here's another tip—maybe you shouldn't buy a dyed photographic muslin at all! Instead, investigate buying a white king-sized cotton sheet and dyeing your own. For non-full length pictures you can easily fit 4 to 6 subjects in front of a king sized sheet if you use a

slight telephoto (portrait length) lens. Dyeing your sheet can be messy and fun. All it takes is a box of Rit™ dye. I've done cotton backdrops with an overall gray dye followed by localized dyeing with black dye applied with a sponge. I use the black dye around the edges of my backdrop and dilute it more and more as I splotch my way towards the center.

96

In this way I PAINT IN A BACKGROUND LIGHTING EFFECT just by the amount of dye I use. That, folks, is Tip #96!

97

© Steve Sint

If you go this route, work outdoors (in the backyard or driveway) and WEAR RUBBER GLOVES WHEN WORKING WITH THE DYE. Hands splotched with gray and black dye don't wash clean!

98

© Steve Sint

Once your background is finished (or bought) you have a choice of how to mount it behind your subject. You can stretch it taut between light poles (see "Oval Holes and Background Poles," page 151) letting its wrinkled self go out of focus or you can clip it up in such a

way as to create swirls and patterns in the cloth (see photos). There once was a famous baby photographer who used a Persian rug as a backdrop for baby photos. If the baby was gorgeous he would throw the intricate pattern of the rug out of focus and if the baby was... how should I say it... a dog, he would make sure the rug's pattern was sharper. Sort of giving the viewer a choice of what to look at I guess! This tip is to use background complexity to help your improve the look of the subject. *P.S. Never, ever tell your subject why you decide on one way or the other!*

99

Attaching a backdrop is easy to do using spring clamps. While my favorites are expensive FOBA™ clamps, if your light poles are thin enough you can use inexpensive oversized paper clips (see photo below) that cost about 40 cents each in stationery stores.

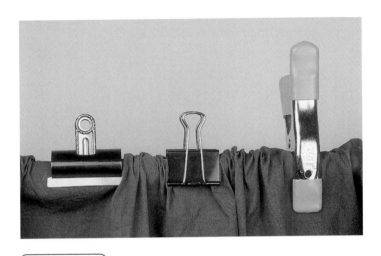

100

Now, get a small nylon ditty bag to store all of your backdrop clips. Keep it inside your background satchel so they're there when you need them. My clip satchel also includes a Bogen® Clamp so I can clamp a hairlight to the cross bar that supports my backdrop. Additionally, I have a few different light stand adapters in my bag so any light stand I have can be used to support my backdrop crossbar. If you get a Bogen clamp and light stand adapters you've just taken advantage of Tip #100.

101

© Steve Sint

Last on my list of backdrop hints is to sew a casing into the top edge of your backdrop. This can be easily done by folding over the top edge of the backdrop and sewing it with a row of stitching. This provides an easy way to hang the backdrop from the crossbar... just push the bar through the tube created by folding over the fabric.

Equipment Sources

Bogen Photo Corp.
565 East Crescent Avenue
Ramsey, NJ 07446-0506
(201) 818-9500
*Bogen-Manfrotto, Elinchrom,
Gitzo, Gossen, Metz*

Dyna-Lite Inc.
311-319 Long Avenue
Hillside, NJ 07205
(800) 722-6638
Comet, Dyna-Lite

Filis Forman
110 West End Avenue
Suite 166 G
New York, NY 10023
*Professional Make-up Touch-
up Kit*

Victor Hasselblad Inc.
10 Madison Road
Fairfield, NJ 07004
(973) 227-7320

Lumedyne, Inc.
6010 Wall Street
Port Richey, FL 34668-6762
(813) 847-5394

Lumiquest
P. O. Box 310248
New Braunfels, TX 78131
(210) 438-4646

Minolta Corporation
101 Williams Drive
Ramsey, NJ 07446-1282
(201) 825-4000
Minolta, Cokin

Quantum Instruments, Inc.
1075 Stewart Avenue
Garden City, NY 11530
(516) 222-0611

The Saunders Group
A Tiffen Company
21 Jet View Drive
Rochester, NY 14624
(716) 328-7800
*Domke, Polaris, Silver Pixel
Press/KODAK Books, Strobo-
frame, Wein*

Tiffen Manufacturing Co.
90 Oser Avenue
Hauppauge, NY 11788
(516) 273-2500

York Ladder
37-20 12th Street
Long Island City, NY 11101
(718) 784-6666
*Little Jumbo ladder by
Wing Enterprises*